IMAGES
of America

MANTEO

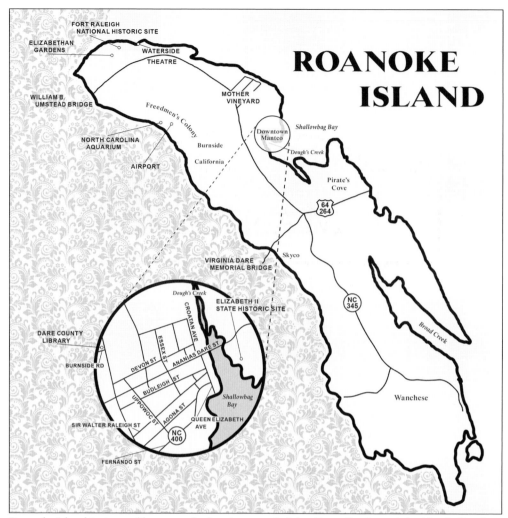

ROANOKE ISLAND

FORT RALEIGH
NATIONAL HISTORIC SITE

ELIZABETHAN
GARDENS

WATERSIDE
THEATRE

WILLIAM B.
UMSTEAD BRIDGE

Freedmen's Colony

MOTHER
VINEYARD

Downtown
Manteo

Shallowbag Bay

NORTH CAROLINA
AQUARIUM

Burnside

Dough's Creek

AIRPORT

California

Pirate's
Cove

64
264

VIRGINIA DARE
MEMORIAL BRIDGE

Skyco

NC
345

Dough's Creek

Broad Creek

DARE COUNTY
LIBRARY

CROATAN AVE

ESSEX ST

ELIZABETH II
STATE HISTORIC SITE

BURNSIDE RD

DEVON ST

ANANIAS DARE ST

BUDLEIGH ST

UPPOWOC ST

AGOMA ST

Shallowbag
Bay

Wanchese

SIR WALTER RALEIGH ST

QUEEN ELIZABETH
AVE

NC
400

FERNANDO ST

Roanoke Island is situated between the barrier strand of the Outer Banks and the North Carolina mainland. It was on the beautiful, wooded north end that the English established the first colony in the New World. This map was first used in a promotional brochure put out by Manteo Booksellers in the 1990s. Since then, a new bridge has been built to the island. (Manteo Booksellers.)

ON THE COVER: In this 1926 photograph, the townspeople of Manteo are vying to catch the first glimpse of approaching boats bringing dignitaries. The celebration of Virginia Dare's birthday was a national event with Sir Esme Howard, British ambassador to the United States, serving as the principal speaker. Sir Howard declared: "Someday, all the world will make a pilgrimage to the spot to do honor to Virginia Dare's memory." (Katherine Midgett Kennedy Collection.)

IMAGES
of America

MANTEO

R. Wayne Gray and Nancy Beach Gray

ARCADIA
PUBLISHING

Published by Arcadia Publishing
Charleston, South Carolina

Printed in the United States of America

Library of Congress Control Number: 2019957192

For all general information, please contact Arcadia Publishing:
Telephone 843-853-2070
Fax 843-853-0044
E-mail sales@arcadiapublishing.com
For customer service and orders:
Toll-Free 1-888-313-2665

Visit us on the Internet at www.arcadiapublishing.com

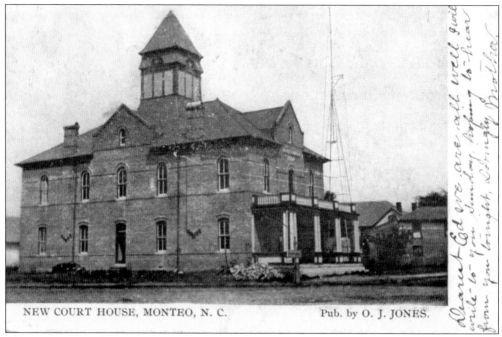

NEW COURT HOUSE, MONTEO, N. C. Pub. by O. J. JONES.

The Manteo courthouse was regal for a small town. Not only was it the center of government for
the county, it was also the hub of social, political, and religious life for the community. Church
services, club meetings, minstrel shows, drama try-outs, and little boys playing chase all took place
in the brick cornerstone of Manteo. (Richard Wayne Gray Collection.)

CONTENTS

ACKNOWLEDGMENTS

We are grateful to a number of people who helped make this book possible by sharing stories and knowledge in interviews and conversations or by giving us historical information and photographs, including some that have never before been published.

No book is a complete product of its author or authors. We talked to many Manteoers who were passionate about their town and shared valuable judgments. We were able to get a perspective of Manteo that we did not formerly have.

For their generous support in the writing of this book, we are indebted to Arcadia Publishing and Caitrin Cunningham, our fantastic editor on three previous books.

We extend a special thanks to Angel Ellis Khoury, who wrote the definitive book on Manteo.

We give much appreciation to the Outer Banks History Center staff, who rendered their time and expertise as they always have.

Thanks to Jami Lanier, who opened the National Park Service archives on Manteo to us, giving us access to rare pictures.

Roanoke Island Historical Association's historian, lebame houston, spent hours identifying pictures in the association's archives and guiding us through many photographs associated with *The Lost Colony*. Our heartfelt thanks go to her.

Jamie Anderson, owner of Downtown Books in Manteo and Duck's Cottage Bookstore, first suggested that we write a book on Manteo and offered much advice and encouragement.

We offer grateful thanks to Ladd Bayliss, Melody Leckie, and John Wilson IV of Outer Banks Conservationists for assisting us with their archives.

Thanks to Pam Daniels Jones and Buddy Boyce, both Manteoers and lifetime friends, who readily shared family pictures that have never been published.

We have the good fortune to be friends with Steve Basnight Jr., Robert Midgette, John Blevins, Alvah Ward Jr., Steve Brumfield, Hubby Blevins, Juanita Wescott, and Pastor Scott Baxley, who were always there to help with our many questions.

Many images in this volume appear courtesy of coauthor Richard Wayne Gray (RWG), the Outer Banks History Center (OBHC), the Roanoke Island Historical Association (RIHA), and the National Park Service, Cape Hatteras National Seashore (NPS, CHNS).

INTRODUCTION

Manteo is located on Roanoke Island, a pristine island between the Outer Banks of North Carolina and the mainland. This unique island, protected from harsh nor'easters and hurricanes, lies directly across from Nags Head. It is approximately the size and shape of Manhattan. Algonquin Indians lived at this location for thousands of years before the first English settlers arrived in 1584. Manteo makes up the northern part of the island, and Wanchese encompasses the southern part. Both sections of the island were named for Native Americans encountered by the area's first colonists. The northern part of the island is comprised of high, sandy areas, whereas the southern part of the island slopes down to mostly marshy areas with a few high knolls crisscrossed by many cuts and creeks. Roanoke Island is separated from the barrier islands by the Roanoke Sound on the east and bordered by the Croatan Sound on the west. The island is historically known as the site of early attempts at English colonization in North America.

On August 13, 1587, three years after colonists arrived on Roanoke Island, Manteo, a Native American, was baptized in the first recorded Christian ceremony in the Western Hemisphere. Virginia Dare, John White's granddaughter, was christened less than two weeks later as the first English child born in the New World.

In 1587, Sir Walter Raleigh's ships, led by John White, made a fourth trip to Roanoke Island with 117 men, women, and children aboard for another attempt at colonization. A short time later, White was encouraged to return to England for supplies. Because of the invasion of the Spanish Armada, he was unable to return to Roanoke Island until 1590. Upon his return, he found no colonists. What happened to them remains a mystery to this day.

This region has always been blessed with abundant resources and cursed—for a long time—by isolation. Permanent settlers found their way to Roanoke Island less than 100 years after the first colonists arrived and eked out a living mostly by fishing, farming, and raising cattle. A lack of roads, bridges, and transportation, along with frequent and severe weather patterns, contributed to the absence of commercial development for many years.

In the early 1800s, the area that would become Manteo was a sleepy village with a ramshackle waterfront with a few wooden buildings and dirt streets. Fishermen brought their catches to the docks to unload them for the markets, but this unnamed site on Shallowbag Bay was certainly not a town. It was more of a wharf where cows and other livestock meandered at will. There were no set rules, and no sanitary conditions existed. There were a few mercantile stores doing some business, but not many people lived in this waterfront settlement. However, it was a meeting place of sorts and would become more active once it was named Manteo and made a county seat.

In 1808, Roanoke Island Baptist Church was built on the north end of Roanoke Island. It was the first church constructed in the area. In 1865, AME Zion Church was built.

Northern Roanoke Island rapidly became crowded during the Civil War as the Union Army, Confederate prisoners, and 3,000 African Americans—known as the Freedmen's Colony—congregated there. In 1870, Dare County was formed, and the little town referred to as Shallowbag Bay (or the Upper End) was made the county seat. A post office was built in 1873, and the town was officially named Manteo. A wooden courthouse was built that same year, and the citizens of Dare County flocked there to pay taxes, register deeds, and have court hearings. Businesses sprung up along the waterfront as new merchants responded to the influx of visitors to the courthouse. In addition, some shipwreck salvage auctions were held in the town.

In 1899, the town incorporated, and Manteo became the center of activity for Dare County and a thriving municipality. It had doctors, lawyers, and other professionals. It boasted two grand hotels, churches, schools, and numerous businesses. It had become a progressive town.

National recognition came a few decades later with playwright Paul Green's outdoor drama *The Lost Colony*. The town quickly changed as most of its citizens turned their homes into boardinghouses for the many tourists coming to see *The Lost Colony*. This pageant was heavily advertised and promoted, bringing thousands of people to the quaint town during each season it was performed.

In 1939, most of Manteo's waterfront buildings burned in a massive fire. As devastating as this was, the townspeople swiftly rebuilt, using brick when possible and expanding the town. Because of bridges and roads, water-based transportation was no longer required. A few years later, Manteo had a front seat for World War II activities as German submarines, prowling close to the coast, torpedoed ships almost every day during the first part of the war. During the World War II era, Manteo hosted hundreds of soldiers, Works Progress Administration (WPA) workers, the National Park Service, and Civilian Conservation Corps (CCC) men.

In 1953, the widely known Elizabethan Gardens, a 10-acre panorama of native flowers and ancient trees, was completed on the north end of Roanoke Island. It was designed by renowned architects to commemorate the first English colonists. The gardens and the enduring success of *The Lost Colony* continued to bring large crowds to the small island. It is safe to say that Manteo would not be the town it is today without its symbiotic relationship with Green's play.

In the 1960s, Manteo underwent a Tudor-style renovation of many of its buildings in an attempt to again revive the town. In the early 1980s, a young architect and Manteo native, John F. Wilson IV, began a revitalization of the town. The waterfront, as well as most of the downtown area, was again rebuilt. New additions to the face of Manteo included Festival Park, with an outdoor pavilion and an indoor theatre; the Outer Banks History Center; and a berth for the *Elizabeth II*, a facsimile of the boat that brought colonists to the area in the 1500s. A celebration with Princess Anne lasted for days and featured all kinds of street entertainment. The 400th anniversary of the arrival of the English was heartily proclaimed on the island where it began.

Today, the renaissance continues anew with Manteo contemplating a fresh 20-year plan of progression. By anyone's standards, Manteo has it all. It is the cradle of the country's birth, and that historic site is protected and celebrated. It is a place of unique natural beauty with waterfront vistas, a maritime forest, and high sandy land. It is a destination for tourists thanks to its museums, modern aquarium, charming shops, and varied restaurants. It is a center of cultural experiences with *The Lost Colony* drama, a local theater group, music and art festivals, and an active arts council. The schools are top-rated, and the churches are influential and vibrant.

But perhaps the most valuable asset of Manteo is its citizenry made up of people who are extraordinarily friendly, kind, and unpretentious. These characteristics are not only held by the natives but are also usually adopted by the people who choose to move to Manteo. Actor Andy Griffith patterned his fictional Mayberry after Manteo, and the characters portrayed on his show embody the essence of the salt of the earth. Griffith once said that the thing that he found most attractive about Roanoke Island was its classless society that allowed everyone an equal opportunity. Historians can attest to the fact that businesses and buildings come and go, but an abiding spirit of a community is a treasure without price.

One

FROM COLONY TO VILLAGE

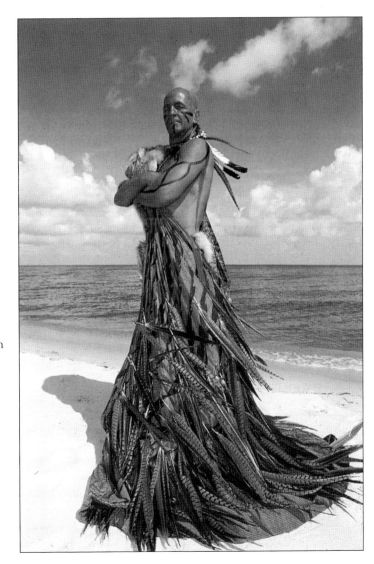

Manteo, depicted here by Robert Midgette on a 1997 promotional postcard for *The Lost Colony*, aided Englishmen Philip Amadas and Arthur Barlowe in their exploration of the New World. Amazingly, Manteo and another Native American, Wanchese, sailed back to London with the explorers, learning of their Elizabethan ways and imparting valuable information about Algonquin language and culture. (RIHA.)

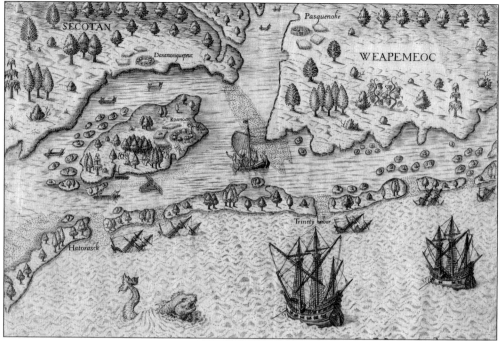

Colonist John White, governor of Sir Walter Raleigh's failed attempt at a permanent settlement on Roanoke Island in 1587, also served as a mapmaker and artist. White's map shows a palisaded village, cultivated fields, and Algonquin hunters at the north end of "Roanoac" Island. After leaving their square-rigged sailing ships and perhaps coming through Trinity Inlet, English explorers prepared to land their small craft. (OBHC.)

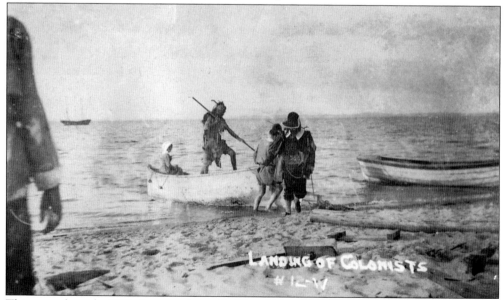

This scene from the 1921 silent movie entitled *Lost Colony* portrays colonists coming ashore. The fate of the 1587 settlers is still unknown. They may have left Fort Raleigh because of hunger or trouble with the natives. They left a prearranged clue as to where they may have gone by etching "CROATOAN" (Hatteras Island) into a tree. (Betty Bruce Stratton.)

Before they disappeared, Ananias and Eleanor Dare became the parents of the first English child born in the New World on August 18, 1587. The infant was christened Virginia Dare six days later. The baby's grandfather, John White, went to England seeking supplies and returned after three years to find the colonists gone. In the production of *The Lost Colony* pictured at right, the part of Eleanor Dare was played by Marjalene Thomas from 1959 to 1965. (OBHC.)

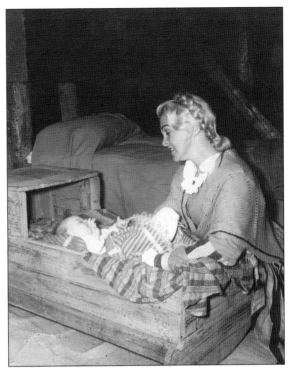

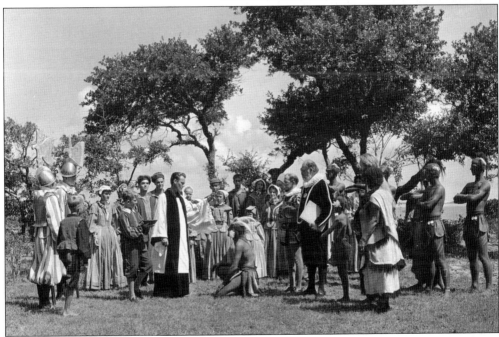

In a ceremony that took place on August 13, 1587, a few days before Virginia Dare was born, Manteo received the sacrament of baptism. This 1960 photograph shows a reenactment of the scene. Manteo, known as the "friendly Indian," helped the 1585 colonists make it through the harsh winter and taught Thomas Harriot the Carolina Algonquin dialect. (Aycock Brown Collection, OBHC.)

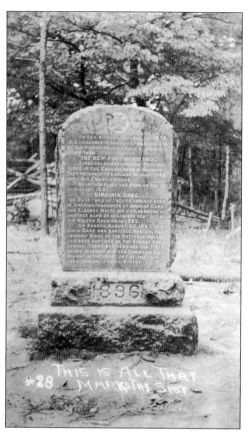

After 300 years, the earthworks and trenches that delineated the original Fort Raleigh still remained detectable, so in 1896, a group calling themselves the Roanoke Colony Memorial Association purchased the 250-acre Dough Homestead, erected a monument to commemorate the settlement and baptisms, and fenced in the earthworks to safeguard them. (Betty Bruce Stratton.)

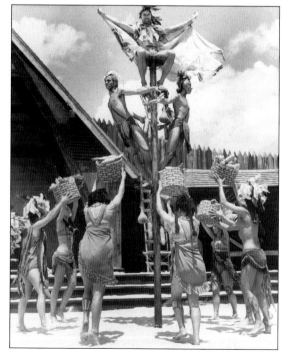

An artistic corn harvest dance was featured in a production of *The Lost Colony* in the late 1960s. Chronicler Thomas Harriot related that the Algonquins had highly developed agricultural techniques, particularly those related to raising corn and cultivating grapes. Roanoke Island had a "wondrous profusion" of grapes, according to explorers Philip Amadas and Arthur Barlowe. (Aycock Brown Collection, OBHC.)

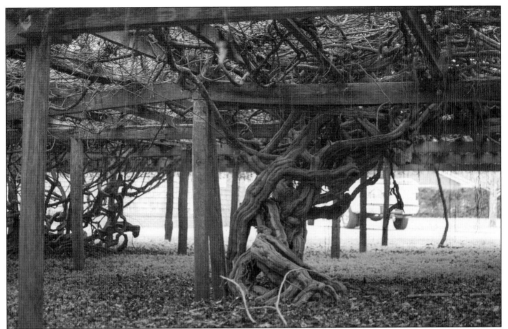

A legend exists that Sir Walter Raleigh's colonists planted a scuppernong grapevine when they made landfall in 1585. That legend is tied to an ancient vine, called the Mother Vineyard, that still produces luscious, greenish-bronze grapes on the property of Jack and Estelle Wilson. Before Jack and Estelle died, they created a nonprofit organization to manage the vineyard in perpetuity. (Francesca Beatrice Marie.)

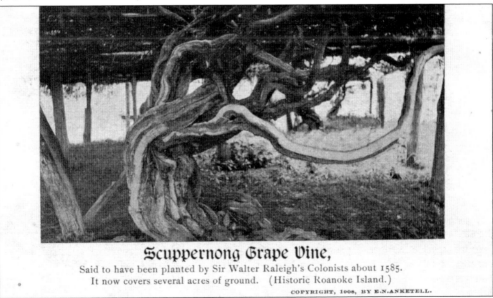

Scuppernong Grape Vine,
Said to have been planted by Sir Walter Raleigh's Colonists about 1585.
It now covers several acres of ground. (Historic Roanoke Island.)
COPYRIGHT, 1908, BY E.N. ANKETELL.

A 1909 postcard confirmed that the original Mother Vineyard was not a single vine but rather five different varietal trunks. William Etheridge, a descendant of Peter Baum, who came to Roanoke Island in about 1715, wrote that he believed the vine to have been propagated by Indians and then rescued by the Baums, who migrated from the premier grape-growing section of Germany. (RWG Collection, photograph by E.N. Anketell.)

After Sir Walter Raleigh's experimental colony failed in 1587, the island was not inhabited by pioneers again until the mid-1600s. Settlers moved to Roanoke Island from the beach after being shipwrecked. Others trickled down from the Tidewater Virginia area or across the sound from eastern North Carolina to start homesteads. Residents subsisted by farming and fishing. (OBHC.)

Wood, used for building homes and boats, was plentiful for early settlers. The dense vegetation on the forested north end of the island may be part of the reason that Fort Raleigh's ruins remained undisturbed for so long. In addition, respect and protection from local families—particularly the Doughs—honored the revered national site as hallowed ground. (D. Victor Meekins Collection, OHHC.)

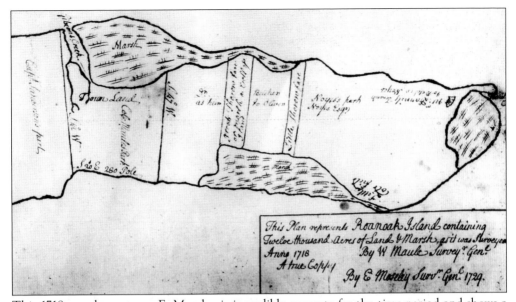

This 1718 map by surveyor E. Moseley is incredibly accurate for the time period and shows a Roanoke Island that is 3 miles wide and 12 miles long. The north end (left side) is obscured, but Gibson's Creek (later Dough's Creek), the future site of downtown Manteo, is clearly shown cutting through a marshy area now known as Shallowbag Bay. (OBHC.)

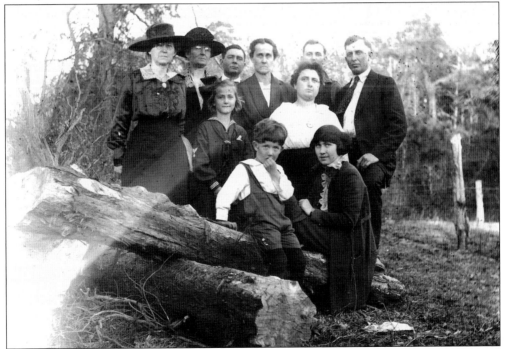

Absentee New England merchants owned much of the island during the 1600s and 1700s and used it to raise livestock. Eventually, individuals—including the Ashby, Baum, Daniels, Dough, Etheridge, Farrow, Mann, Meekins, Midgett, and Wescott families—acquired land tracts. This photograph features Dough and Etheridge family members. Descendants of these early settler families still live on the island. (D. Victor Meekins Collection, OBHC.)

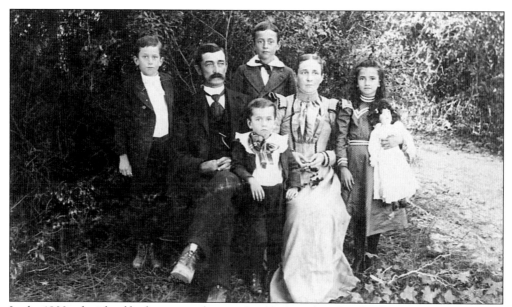

In the 1800s, the island had access to the mainland by boat, but the islanders remained somewhat isolated from the rest of the country in their thinking. They rarely got caught up in national politics. Very few families had slaves, so when the slavery conflict arose and the question of succession came about, most Outer Bankers were ambivalent about the idea. (D. Victor Meekins Collection, OBHC.)

It is not known if Micajah "Caje" Etheridge was sympathetic to the Northern cause, but the majority of residents were during the the Civil War. A pro-Union stance may have been in order because of the reliance on federal jobs with the US Life-Saving Service and at lighthouses. Enoch B. Kirby, a Union soldier, wrote in a 1862 letter, "…the inhabitants on the island are well pleased with our soldiers and are glad we took the island for the rebels would not leave them nor [let them] set their nets." (D. Victor Meekins Collection, OBHC.)

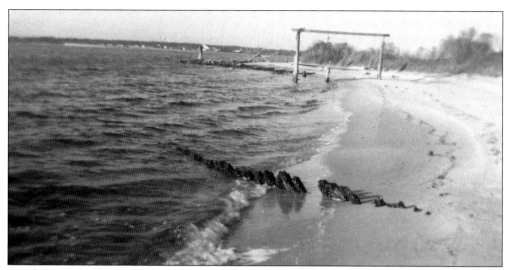

Confederate forces seized Roanoke Island because it was considered a gateway to Albemarle Sound and its port cities and a back entrance to Norfolk, Virginia. A barricade of sunken boats and pilings (their remnants are shown in this 1938 photograph) was erected between Fort Bartow on Roanoke Island and Fort Forrest on the mainland to block Union warships. (NPS, CHNS.)

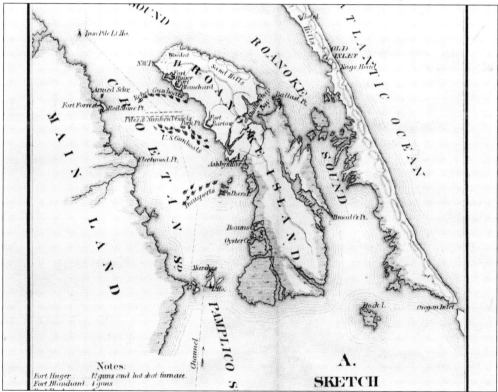

In this Civil War–era map, three Confederate strongholds—Fort Huger, Fort Blanchard, and Fort Bartow—protected northern Roanoke Island's west side. Rebel gunboats lay in wait north of the barricade, but federal gunboats were on the other side making their way from Hatteras Island to the deeper waters of Ashbys Harbor, near present-day Skyco. (OBHC.)

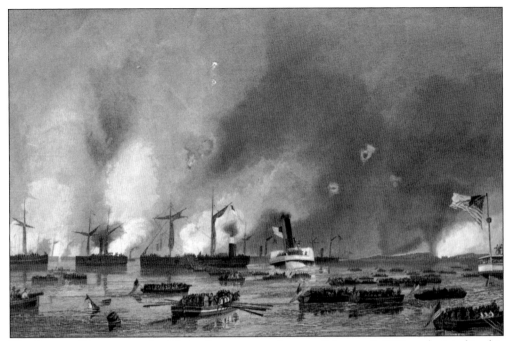

The Stars and Stripes waved as Union forces came ashore on February 7, 1862, as depicted in this rendering of the Battle of Roanoke Island. After waiting out the night, at daylight, Union soldiers advanced through swamps that Confederates thought were impenetrable. A soldier later wrote that they slogged through the winter marsh in water depths ranging from knee-high to over their heads with bullets whizzing all around. (RWG Collection, *Harper's Weekly*.)

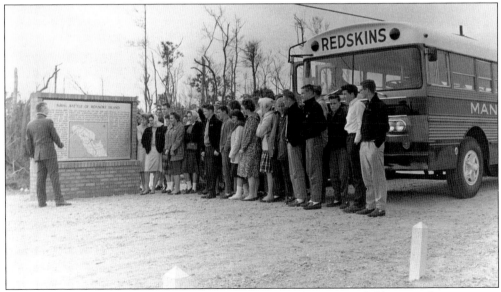

In 1962, Manteo High School students experienced a short-range field trip and an open-air classroom when they traveled to see a newly erected highway marker commemorating the spot where a Confederate force of 400 men and three cannons tried to resist the landing of the Union army under Gen. Ambrose Burnside. The Confederates surrendered after being driven back by 7,500 Federalists. (OBHC.)

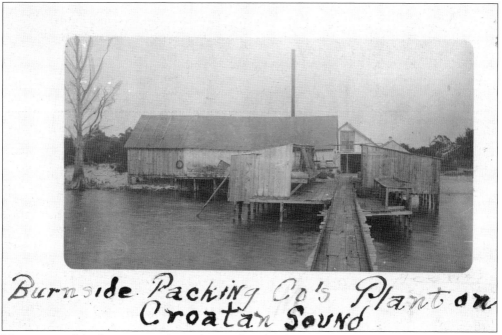

Burnside Packing Co's Plant on Croatan Sound

Union general Ambrose Burnside used Roanoke Island as a staging area for other assaults in the months before taking his forces to Virginia in July 1862. A west side Manteo neighborhood was named after Burnside. The Burnside Packing Company plant located on Croatan Sound in the early 20th century had a long wharf with a tram on a track for unloading fishing boats. (D. Victor Meekins Collection, OBHC.)

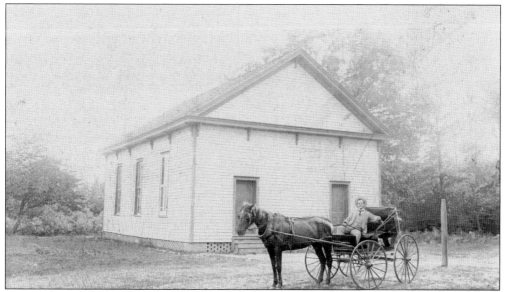

The original 1808 Roanoke Island Baptist Church was burned by Union troops because Confederate sympathizers were said to be meeting there. The second church (shown here) was rebuilt in 1886 after members petitioned the government for aid, and received only wood from a nearby, dismantled Union hospital. Modern updates and a large addition have kept this historic church firmly in the present. (Roanoke Island Baptist Church.)

19

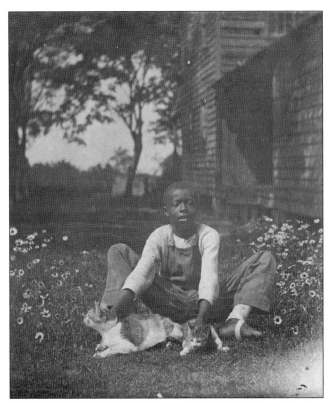

When word of the Union victory spread, escaping slaves traveled to Roanoke Island for refuge. The first boatload arrived from the mainland after dodging shotgun fire on the Chowan River and crossing 35 miles of sound waters. The 20 men, women, and children were led to Gen. Ambrose Burnside, who promised he would not return them to their former owners. (D. Victor Meekins Collection, OBHC.)

The contrabands, later called freed people, kept coming. They lived in abandoned Confederate buildings and barracks. The Union army gave them supplies and jobs cooking, chopping wood, and doing laundry for the troops. This engraved granite marker honoring the Underground Railroad was erected at the Fort Raleigh National Historic Site in 2001. The etching shows the hope and longing for freedom among the enslaved people. (RWG.)

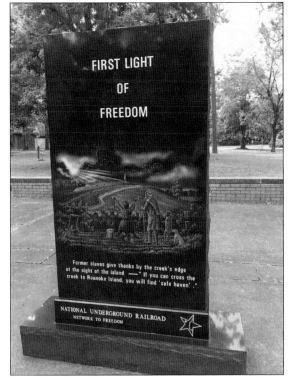

FIRST LIGHT OF FREEDOM

Former slaves give thanks by the creek's edge at the sight of the island ——". If you can cross the creek to Roanoke Island, you will find 'safe haven'."

NATIONAL UNDERGROUND RAILROAD
NETWORK TO FREEDOM

Roanoke Island Freedmen's Colony was one of many similar settlements in the country. In 1863, as the population continued to swell, Brig. Gen. Edward Wild took control of unoccupied lands, parceling them out for freedmen family ownership. To the detriment of the community, he also recruited all of the able-bodied black men to fight for the Union. (D. Victor Meekins Collection, OBHC.)

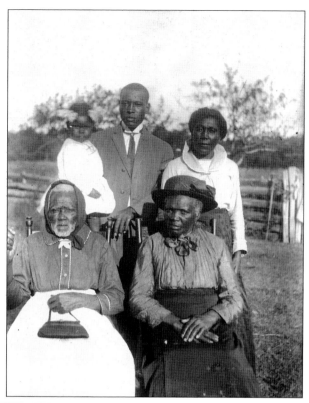

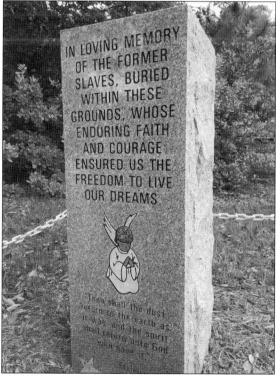

Northern missionaries were brought to Roanoke Island to serve as educators. The superintendents had dreams of the colony being self-supporting, but the reality was that food, supplies, and clothing were in short supply. By 1864, about 3,000 settlers lived in substandard conditions. A modern tombstone near the Dare County Airport remembers those freedmen who died, including some 400 who perished during a cholera outbreak. (RWG.)

The slaves knew they could find safe haven if they could get across the "creek." The name chosen for Manteo's Haven Creek Baptist Church memorializes the freedmen's colony. This 1995 picture shows Erleene Simmons, a descendent of those colonists, prepared to sing a hymn with her fellow Haven Creek choir members. (Drew Wilson Collection, OBHC.)

Just like in the English colony, the people of the freedmen's colony were scattered. When the war ended, rations were cut off, and the land upon which the freed people were living was returned to its prewar owners, like the Meekins family (shown here). However, about 300 former slaves remained, and they became productive citizens and established their own neighborhood called California. (D. Victor Meekins Collection, OBHC.)

Two

THE FORMING
OF A TOWNSHIP

The leader of one of Raleigh's voyages, Ralph Lane, said that Roanoke Island and the surrounding area were the "goodliest soile under the Cope of Heaven." Living in a place of natural beauty and bounty helped 400 citizens recover from years of Confederate and Union occupations. They may have felt like prisoners on their own island as they had land, boats, farm animals, and supplies taken from them. (OBHC.)

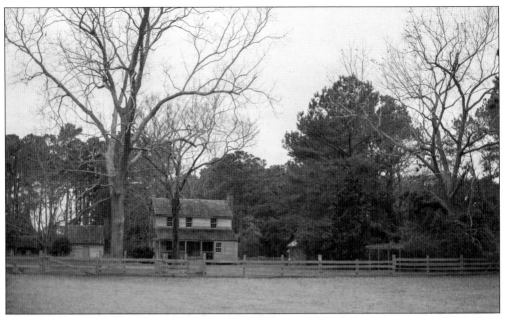

The Island Farm, a living history site on the north end of the island, exists to help modern people understand what life was like in the 1800s for the Etheridge family. Some farms were for subsistence, but other homesteads grew enough fruit, produce, and livestock to ship to Norfolk and beyond. One neighboring farm had a peach orchard and cannery and another had a two-acre vineyard and winery. (Francesca Beatrice Marie.)

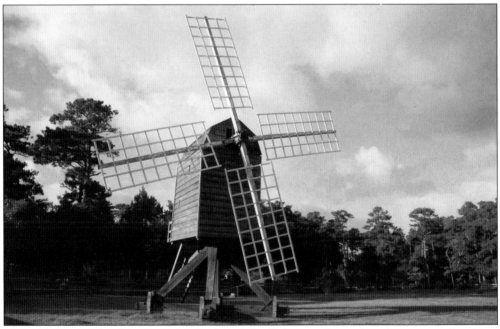

The Island Farm also features a replica of a windmill that was located in the vicinity. Residents called the north end of the island Logtown because of the numerous log corncribs that dotted the landscape. Eventually, they gave way to attractive homeplaces like the one owned by Augustus H. Etheridge, who kept his fences and trees whitewashed. (RWG.)

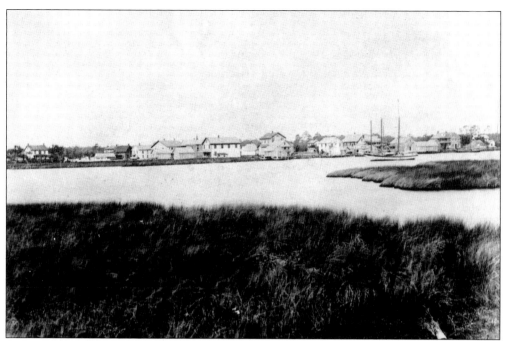

A decade after the Civil War, a town had grown up around the waterfront of Dough's Creek that led out to Shallowbag Bay. The sandy streets were lined with businesses and homes. The plots were big enough for each family to have a large garden behind their house. Livestock wandered at will, and fences were constructed to keep them out rather than to keep them in. (Pam Daniels Jones.)

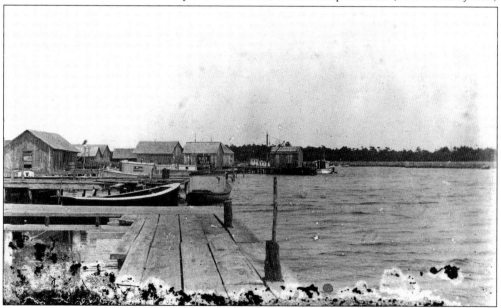

At one time, crabmeat was canned, and oysters and scallops were shucked in wooden factories along the waterfront. The docks were the heart of the community. Roads were very poor, and bridges did not exist. The only way for goods and people to travel in and out of the area was by water. The lack of a deep port hindered significant commercial development in the region. (D. Victor Meekins Collection, OBHC.)

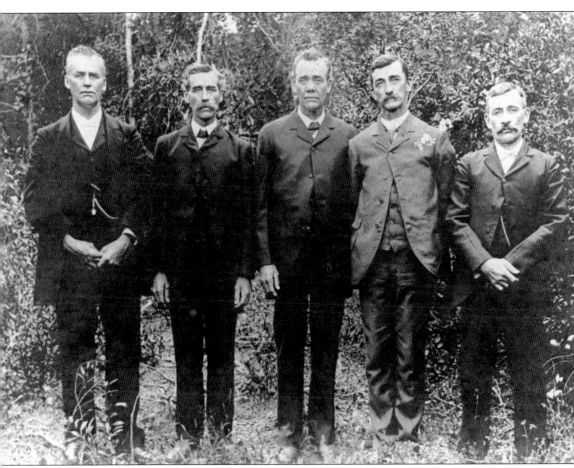

The Evans brothers of Chowan County were progressive, hardworking men who recognized opportunities were to be had on Roanoke Island. Pictured here are, from left to right, John, Elisha, Albert, Asa, and Richard. All but Elisha moved to the island. During their lifetimes, the new county of Dare was formed from portions of Hyde, Tyrrell, and Currituck Counties, and Manteo became the county seat in 1870. A post office was built in 1873, and Manteo was officially chosen as the name for the Shallowbag community. The Evans men shared a driving purpose to create a town that would be the governmental and commercial center of Dare County. The General Assembly of North Carolina ratified a charter incorporating the town in 1899, empowering it to adopt ordinances, assess taxes, and implement public works projects. The Evanses were at the center of it all, with family members serving as commissioner, chairman of the school board, postmaster, merchant, innkeeper, wheelwright, blacksmith, and even undertaker. (*Manteo, A Roanoke Island Town* Collection, OBHC.)

Richard "Dick" Evans, shown here in later years, fulfilled his life's dream. His daughter Edna Evans Bell wrote, "When I was a young girl, I remember hearing my father say, 'I always wanted to build up a town around me.'" His generation saw so much change that it was fitting that he posed with both his horse, General, and his luxury Paige car. (OBHC.)

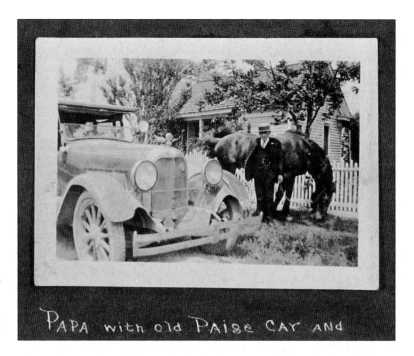

Papa with old Paige car and

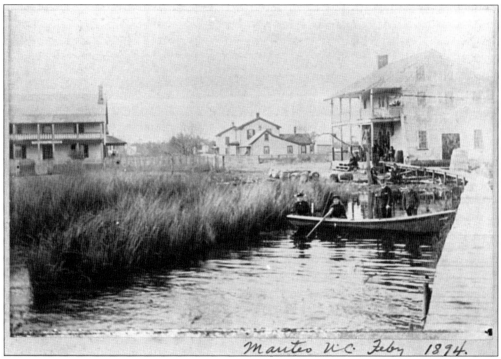

Manteo N.C. Feby 1894.

Yards north, up Dough's Creek, a shad boat was brought around sideways so that the well-dressed party could have their picture taken in February 1894. The barrels in the yard of the building on the right may indicate that it was a place where fowl or fish were packed in salt for shipping. The Tranquil House hotel (on the left) welcomed traveling salesmen and tourists who came to hunt and fish. (OBHC.)

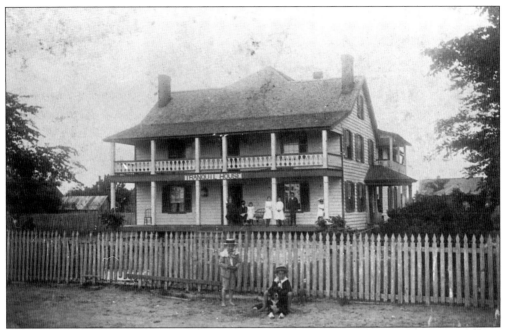

A boardinghouse owned by Judge W.W. Chaddic was purchased by Dick and Asa Evans in the early 1880s and named Tranquil House. The business-minded brothers wanted to turn the large structure into an inn that would appeal to visiting sportsmen. Asa's wife, Celia, gave the establishment a good reputation thanks to her delicious meals of fish, oysters, and game served with homegrown vegetables. (OBHC.)

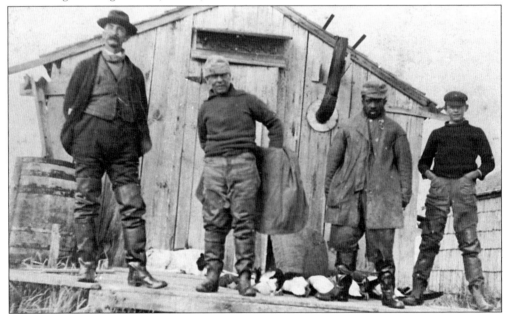

As part of the services offered by the Tranquil House, Asa Evans (left) acted as a guide to duck and goose hunters, hosting them at his small camp in the Roanoke Sound. The accommodations were rugged, unlike those at nearby privately owned clubs and the upscale lodges of Currituck, but the hunting and companionship kept Northerners coming back. (OBHC.)

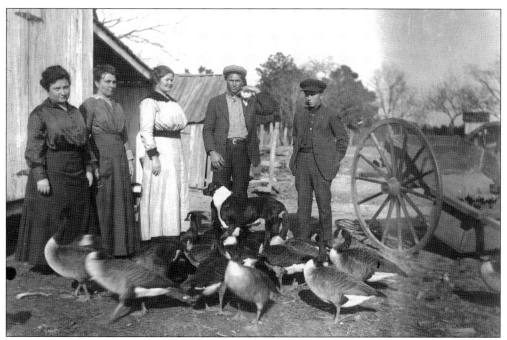

Although hunting for the open market rarely took place on the island, hunters from other areas brought their salted waterfowl to Manteo for shipment. Local guides used live geese as decoys, tying them together in a line to differentiate them from wild geese being lured in. Called tollers, these live decoys were kept at a family homestead. (D. Victor Meekins Collection, OBHC.)

In 1899, the Hotel Roanoke, shown here with its expansive porches and railings, brought competition to the Tranquil House. Builder Nathaniel Gould only ran the hotel for four months before Dick and Delia Evans took over operations. Both hotels stayed full, catering to tourists, drummers, fish dealers, and businessmen looking to invest in Manteo. (OBHC.)

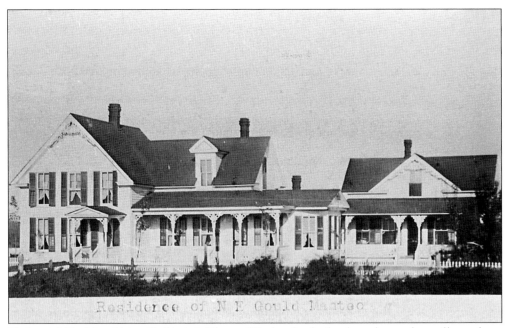

Residence of N I Gould Manteo

Nathaniel Gould and his wife, Lizzie Midgett of Rodanthe, built a large home that still stands on Manteo's waterfront. He patterned it after a house in his hometown of Chatham, Massachusetts. At one time, Gould ran the Bodie Island Hunt Club and managed the Pea Island Club. In 1917, the Goulds, who built the Hotel Roanoke, again became innkeepers when they purchased the Tranquil House. (Charles D. Evans Family Collection, OBHC.)

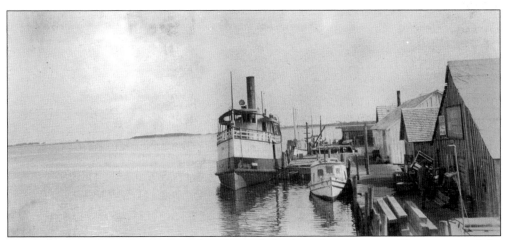

Native-born Will Griffin was another forward-thinking businessman. He saw a need for transportation and purchased boats not only to carry freight and mail but also to bring visitors to Manteo. His finest steamer, the *Trenton,* had lavish accommodations for guests. A traveler could take a train to Elizabeth City and catch the *Trenton* to Nags Head or Manteo. (Betty Bruce Stratton.)

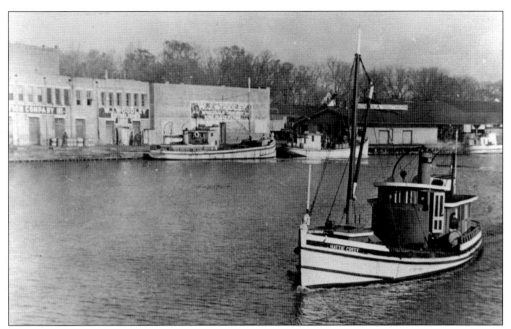

No other boat in eastern North Carolina put in more sea time than the *Hattie Creef*, a round-bottomed, two-masted schooner built by George Washington Creef Jr. The *Hattie Creef* could take rough waters, carry a heavy load, and navigate shallow areas. Will Griffin bought the boat, which was originally used for oystering, for his transportation line. Later, it was a mainstay on E.R. Daniels's Wanchese line. (Museum of the Albemarle.)

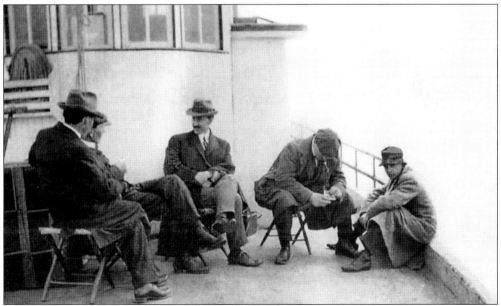

Many times, the Wright brothers took the *Hattie Creef* to Manteo and stayed at the Tranquil House before making camp at the base of Big Kill Devil Hill. According to author and historian Larry Tise, they "had learned the Carolina transportation and communication infrastructure could satisfy their every need." In this photograph taken during his later years, Wilbur Wright (center) sits in the midst of reporters on the *Hattie Creef*. (Museum of the Albemarle.)

Island fishermen received a decades-long windfall when they began bringing in massive catches of shad fish after the Civil War. George Washington Creef Sr. designed a new boat to handle the heavy loads; Creef used curved cypress roots to achieve a rounded bottom. Loran Midgett (left) saw the last part of the great shad runs that ended in the 1920s. (Katherine Midgett Kennedy Collection.)

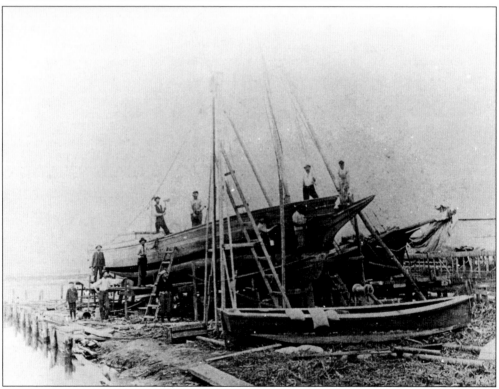

The Creefs continued to use their family boatbuilding knowledge and skills derived from George Washington Creef Sr. when they established Creef Boatworks on the southern Manteo waterfront. Plenty of schooners and sloops were hauled up on the rails for repair by brothers George Jr. and Ben. Today, the Roanoke Island Maritime Museum occupies the spot where Creef Boatworks once stood. (OBHC.)

On the north end of the island, Otis Dough and his sons Lee, Horace, and Worden built sturdy shad boats quickly and cheaply for fishermen, hunters, pleasure boaters, and the government. Their craftsmanship is on display in the champagne glass stem–shaped stern that Lee Dough is standing next to in this image. Shad fisheries greatly enhanced the economy of Manteo. (OBHC.)

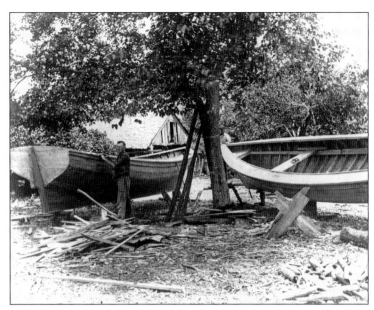

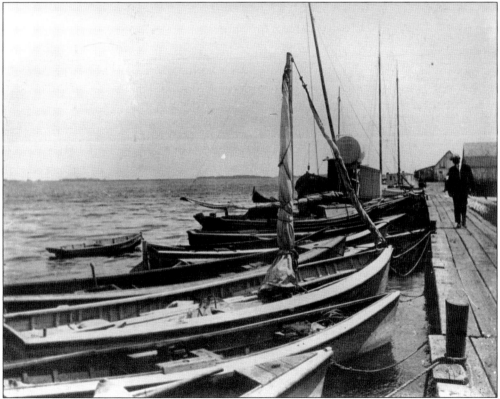

Skiffs and sailboats are shown tied closely together on court day. After a wooden courthouse was built on the waterfront in 1873, people from all over the county came to attend court, record deeds, obtain licenses, and pay taxes. The courthouse was also used for social gatherings, church services, Odd Fellows meetings, political rallies, and entertaining performances. (D. Victor Meekins Collection, OBHC.)

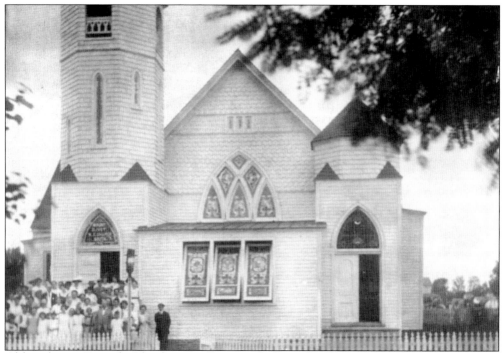

Although most Roanoke Islanders were Baptists, the Evans brothers were Methodists and desired a church for their denomination. Dick Evans and his family worked hard, obtaining land and $600 in contributions. The fledging congregation held services in the courthouse until Mt. Olivet Methodist Church was built in 1889, and this remodeled version with stained glass was completed in 1907. (Mt. Olivet Methodist Church.)

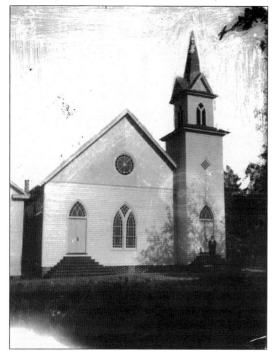

The freed slaves who made up the original Haven Creek congregation built a church in 1865. The second Haven Creek Baptist Church, pictured here, was built on Burnside Road in the late 1880s and was demolished by a hurricane in 1944. It is no wonder that the third church was constructed of brick and still serves its members today. (D. Victor Meekins Collection, OBHC.)

In 1905, 21 members withdrew from Roanoke Island Baptist Church and established Manteo Baptist Church. After churches were in place, thoughts turned to the need for a good school. Some white families could afford private teachers but had a hard time getting them to stay on the island. The population was growing, and education for every citizen was becoming a necessity. (OBHC.)

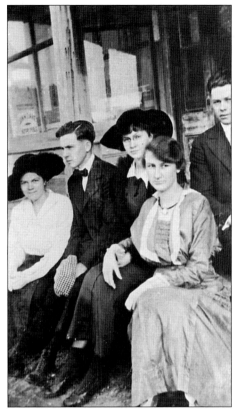

A recently organized fraternal order of Odd Fellows agreed to construct a two-story building large enough to be used as a school downstairs and a lodge hall upstairs. Roanoke Academy, complete with a bell tower, opened in 1894. Two hired teachers—a brother and sister—each managed to teach several class levels at one time. (Katherine Midgett Kennedy Collection.)

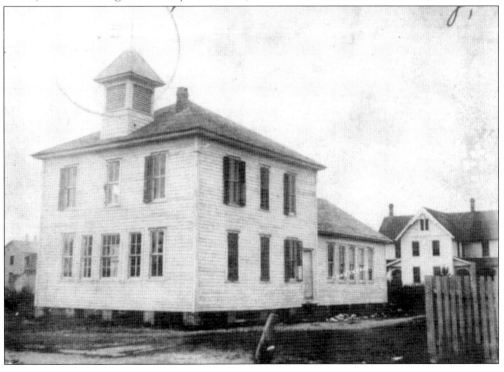

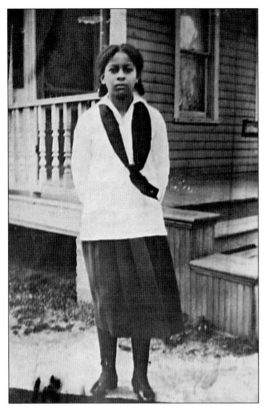

The schoolgirl pictured here in the 1920s may have known that the first formal school on Roanoke Island was for freed slaves. The school was established by the American Missionary Association in a log cabin. Better schools were later built with lumber produced by the freedmen's colony's sawmill. In 1865, before the freedmen's colony disbanded, there were 1,297 black children in need of instruction. (OBHC.)

In the 1920s, siblings Charlie and Mamie Gregory may have attended one of three different schools in Colored District No. 1. Education for black children only went to the third grade, and classes were only held in the summer. Parents often sent their children to Elizabeth City, where they lived with relatives or in boardinghouses so that they could attend upper grades. (D. Victor Meekins Collection, OBHC.)

Three

COMMERCIAL CAPITAL OF THE COUNTY

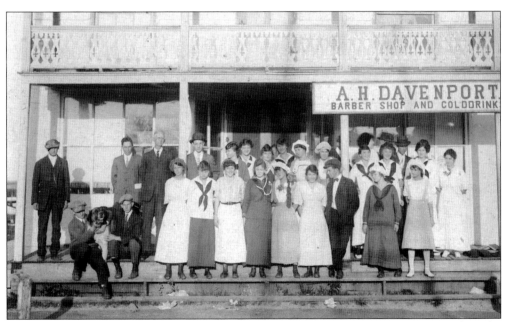

Dressed in their finest, these young people were most likely having a celebration within the store's parlor, where hand-cranked ice cream was featured. The shop's proprietor, A.H. Davenport, like most Manteo businessmen, had many other duties besides barber and merchant. He served as a firefighter and an early town marshal (the agent of law enforcement). (D. Victor Meekins Collection, OBHC.)

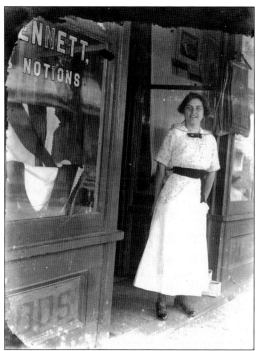

Clerk Elizabeth Quidley Parkerson is shown standing in the doorway of the notions store owned in part by Jabez Jennett. A founding father who also served as a clerk of court, Jennett also sat on the newly formed Manteo Board of Commissioners. He and other prominent men attempted to form an institution for investigating and teaching useful arts and sciences, but it lacked funding. (D. Victor Meekins Collection, OBHC.)

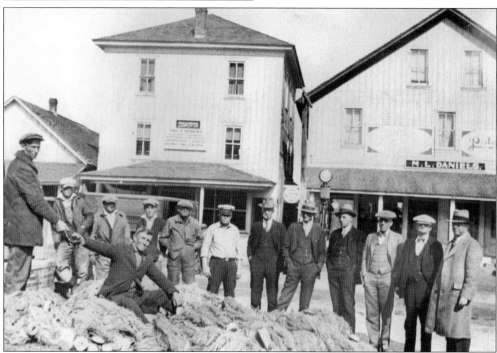

When an abandoned oceangoing ship came ashore, opportunists would strip it down to the ribs, even taking the wooden planking. Shipowners and captains demanded a fairer process, and wreck commissioners were appointed as overseers. The commissioners were in charge of selling salvaged goods in an auction, like this one that took place in Manteo, to recover a portion of the loss for the owners. (Stick Collection, OBHC.)

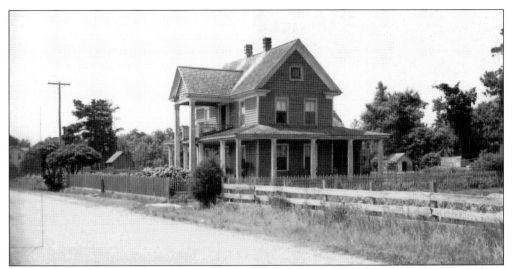

The National Park Service labeled this 1936 photograph as representative of a typical Roanoke Island home. It was typical for earlier times, too, in that there was a roof with cedar shakes, siding made of unpainted boards, chimneys for wood-burning fireplaces, and porches for socializing in cool breezes. A fenced-in, tidy yard flaunted cultivated camellias and snowball hydrangeas. (NPS, CHNS.)

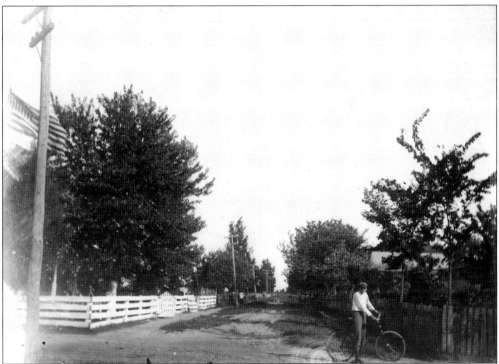

Fields, as well as homes, bordered town roads that were more rural than urban. Shortly after Manteo was incorporated, the streets were laid out in an orderly grid. Existing streets were connected, and drainage ditches were dug. Sidewalks were constructed, and six kerosene street lamps were installed. The town marshal inspected home privies and hog pens to enforce sanitation rules. (D. Victor Meekins Collection, OBHC.)

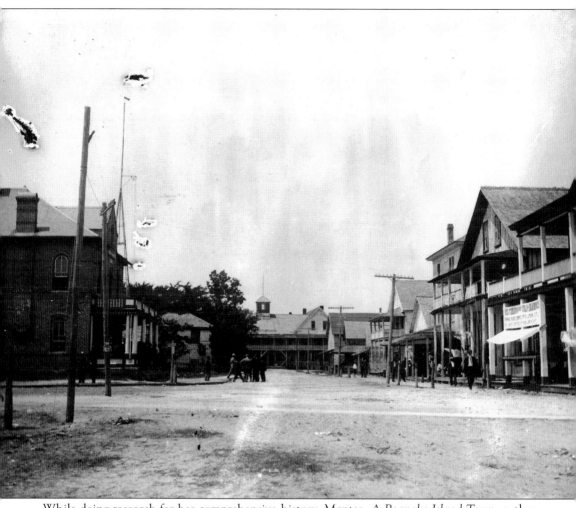

While doing research for her comprehensive history, *Manteo: A Roanoke Island Town,* author Angel Ellis Khoury read through editions of the weekly newspaper *Fisherman and Farmer,* published from 1887 to the early 1900s in Edenton, North Carolina. She found an editorial entitled "How To Build Up a Town." A portion of the piece reads: "Push it. Talk about it. Write about it. Speak well of it. Help to improve it. Beautify its streets. Patronize its merchants. Advertise in its newspapers. Prefer home enterprise always. Speak well of its enterprising men. If you can't think of some good word to say keep silent. If you are rich invest in something; employ somebody; be a hustler. Be courteous to strangers that come among you; so that they will go away with a good impression. Always cheer up the man who goes in for improvement." This editorial may not have been clipped by the town's founding fathers, but the philosophy was imbedded in their hearts as they tirelessly worked to improve Manteo. By 1914, a brick courthouse had replaced the wooden one, and telephone poles were in place. (D. Victor Meekins Collection, OBHC.)

By the 1911–1912 school year, the county had grown enough to provide eight months of free schooling for students in grades one through seven. In 1911, a new principal, F.M. Eason (second row, center), organized a high school with 25 eighth-grade students. The children shown here are dressed in fashionable attire. (D. Victor Meekins Collection, OBHC.)

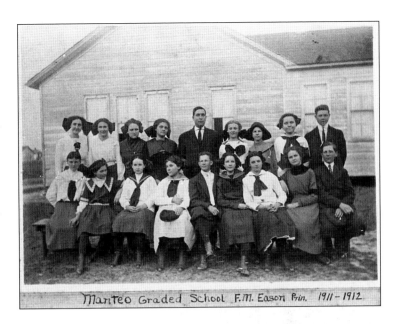

Manteo Graded School F.M. Eason Prin. 1911–1912

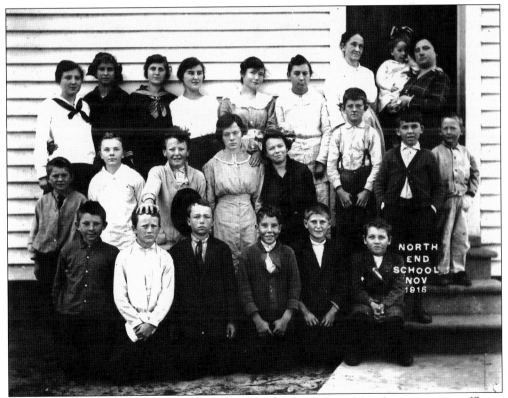

In contrast to the previous photograph, it is obvious that north end families were not as affluent as town dwellers, nor were their conditions as sufficient. The single-teacher school was just for elementary grades until 1912, when older students were sent to Manteo to continue their education. However, some dropped out to go to boarding school or to start work. (D. Victor Meekins Collection, OBHC.)

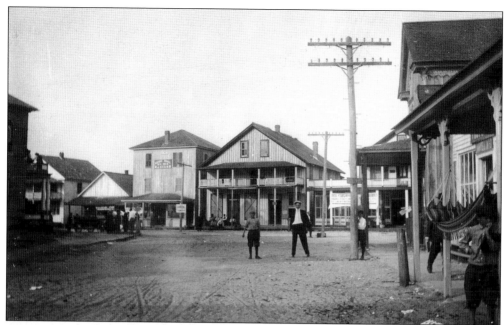

Born in 1897, Victor Meekins was fascinated with photography and became, according to historian Wynn Dough, "the first native photographer to produce a large body of work of both historical and artistic value." At a time when photography equipment was hard to transport and set up, Meekins seemed to be everywhere capturing island life. (D. Victor Meekins Collection, OBHC.)

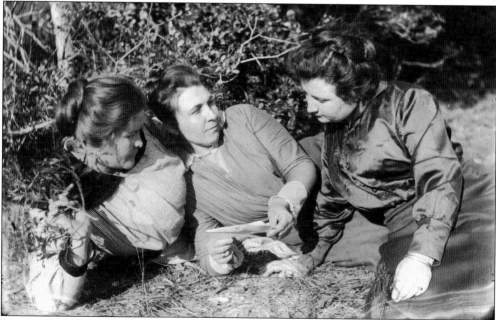

Martha Twiford Rogers (left), Lizzie Midgett Dough (center), and Martha Meekins Dough strike relaxed poses unlike the usual stiff postures of the time. Victor Meekins created a collection of glass negatives spanning the years between 1912 and 1930. He did not pursue photography as a career but went on to be a postmaster, county sheriff, and chairman of the county board of commissioners. (D. Victor Meekins Collection, OBHC.)

Another unusual aspect of Meekins's work was that he often photographed black families. John Frank Wise is shown here working at his cobbler's bench. In 1906, Manteo, with a population of 812, had a variety of businesses, including blacksmith and carriage-maker shops, a confectionary, a millinery, a pharmacy, insurance and real estate agencies, and four doctors. (D. Victor Meekins Collection, OBHC.)

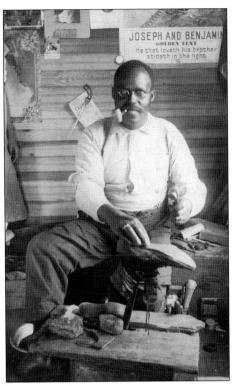

In later years, it was Victor Meekins's turn to have his photograph taken. The newspaperman and founder of the *Dare County Times* (wearing overalls in this picture) used his forum to promote Manteo and encourage economic development. His style of writing had a bite when relating gossipy small-town talk and expressing his strong opinions. It made for entertaining reading that sold papers. (OBHC, photograph by the *Daily Advance*.)

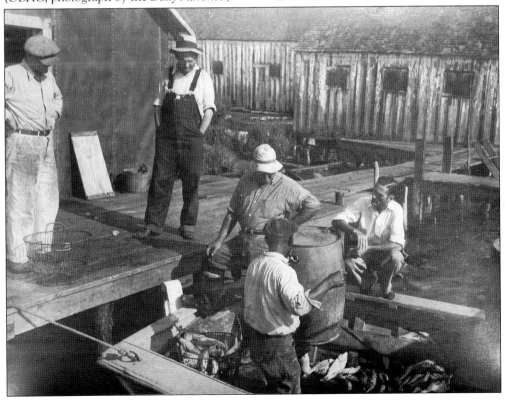

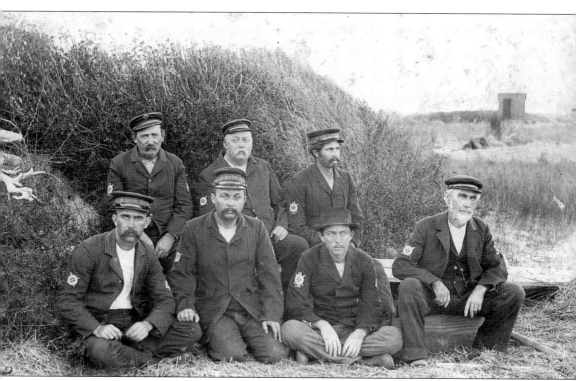

As a result of political pressure, the US Life-Saving Service was established after devastating losses of life and property came about from numerous shipwrecks, particularly off of the Carolina coast's barrier islands. A high percentage of Roanoke Islanders were chosen for the federal jobs, in part because of their knowledge of the ocean. Steady paychecks, in addition to government contracts for station and lighthouse supplies, were of great benefit to Manteo. Surfmen had the mundane task of walking miles along the beach in daily patrols. They also had instances of intense emergency as they performed rescues at sea, truly laying down their lives for others. Assigned to the New Inlet Station were, from left to right, (first row) Bannister Davis, John Hayman, Clement "Dode" Forbes, and George Wescott; (second row) Micajah "Caje" Etheridge, Jim Willis, and Bob Wescott. Many men, including George Wescott, were credited as saying, "you have to go out; you don't have to come back." This became the unofficial motto of the US Life-Saving Service, which became the US Coast Guard in 1915. (Juanita Wescott.)

Manteoers and surfmen Adam Etheridge (left) and John T. Daniels (center) left the Kill Devil Hills Lifesaving Station on December 17, 1903, to assist Orville and Wilbur Wright in their flying experiments. They witnessed the first flight that day, and Daniels snapped a famous photograph. In 1939, Kitty Hawker William Tate (right) joined them to attend a museum opening in Michigan. (NPS, CHNS.)

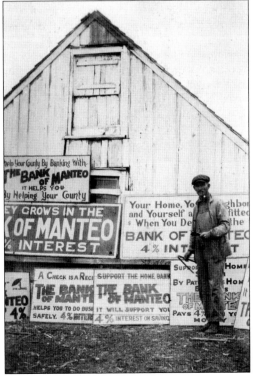

With paintbrushes in his hand, this worker seems to be refurbishing signs for the Bank of Manteo. The bank was incorporated in 1905 with an authorized capital of $40,000 put up by mostly local shareholders. Dick Evans served as the first president, and Will Griffin as the vice president. During the Great Depression, the bank was one of the few that did not fail. (D. Victor Meekins Collection, OBHC.)

Dr. Reginald Fessenden, often called the Father of Radio Broadcasting, came to the Outer Banks to experiment with audio transmissions. He built two 50-foot towers, one in Buxton and one on Roanoke Island's north end, successfully transmitting messages between the two. He stayed in Manteo hotels around the time that the Wright brothers were passing through. (OBHC.)

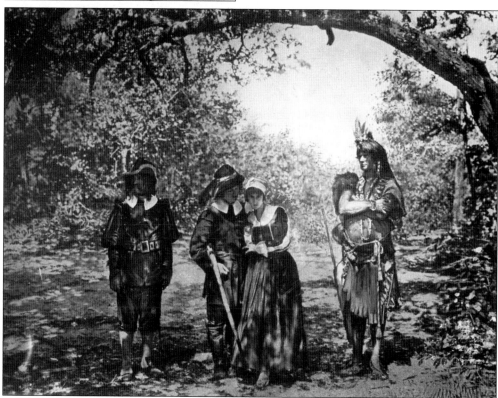

Mabel Evans Jones (center), the daughter of Dick and Delia Evans, was a well-educated thinker who got things done. After starting her career as a high school teacher, she was appointed Dare County superintendent of schools—the first woman in the state to achieve such a position. While studying at Columbia University in New York City, she was exposed to silent movies as an art and a form of education. (OBHC.)

Mabel Evans Jones wrote, produced, and acted in a silent film about Sir Walter Raleigh's colony that was made as a visual education project for schoolchildren. She petitioned the North Carolina Department of Public Instruction for funds to hire a moving-picture outfit. Professional director Elizabeth Grimball (left), from New York, and a camera crew from Chicago arrived in 1921 to make their magic. (OBHC.)

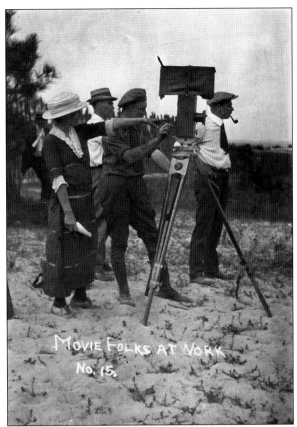

With ceaseless enthusiasm, Mabel Evans Jones recruited locals to act as Indians and colonists in the film. Her father, Dick Evans, turned over the first floor of the Hotel Roanoke as a workshop that could be used for sewing costumes and building sets. Townspeople traveled to the historic Fort Raleigh site each day in two-wheeled carts or Model T cars or by hopping aboard a state fisheries or Coast Guard boat. (OBHC.)

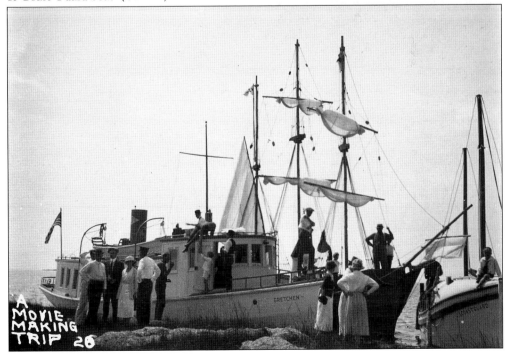

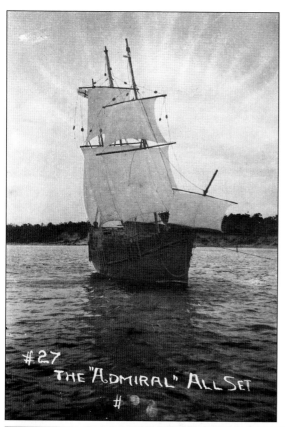

#27
THE "ADMIRAL" ALL SET
#

Roanoke Islanders had long been known for making do with what was at hand. They stretched canvas over a shad boat, created masts and sails, and produced a convincing Spanish galleon. It seemed as if almost all the local families had an actor in the film, which had a cast of 125. Mabel Evans Jones played the part of Eleanor Dare in the five-reel movie that was shown in classrooms across the state for decades. (OBHC.)

With wigs made of unraveled blackened hemp rope and costumes made of felt dyed in washpots, the chiefs and braves aimed to look authentic. They tanned their skin with theatrical greasepaint. The set crew constructed the palisaded fort in the background approximately on top of the 16th-century original. Also, part of the set was an Indian village based on one of John White's paintings. (OBHC.)

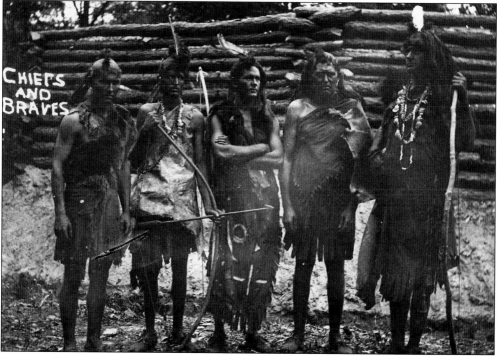

CHIEFS
AND
BRAVES

Four

BRIDGES TO THE OUTSIDE WORLD

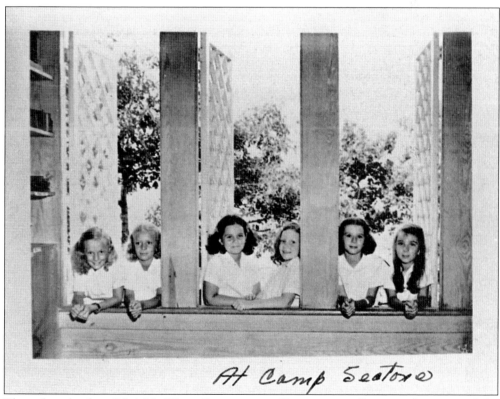

At Camp Seatone

Throughout her long life, Mabel Evans Jones promoted her passions of history, education, and the arts. She rolled all three into one when she operated Camp Seatone on the north end starting in 1933. Off-island and local children would stay in buildings that Jones designed and enjoy acting, dancing, writing, and painting. Of course, horseback riding and swimming in the sound were also favorite activities. (OBHC.)

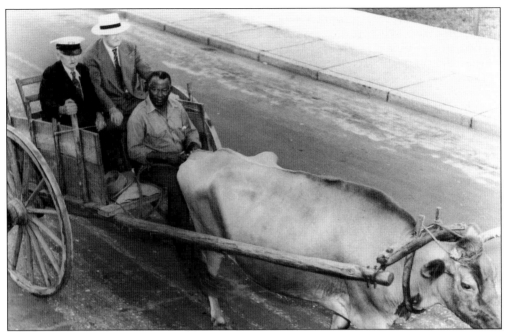

In the 1950s, oxcart-owner George Harvey Midgette (right) honored Capt. Jeff Hayman (left) and Washington Baum (center) by driving them in a parade. Baum saw the need for a bridge between Roanoke Island and Nags Head. When he became chairman of the board of commissioners, he pushed for a mile-long wooden bridge that was built in 1928. (Aycock Brown Collection, OBHC.)

At a time when bootlegging was the county's largest industry, the new Washington Baum Bridge was a step in an unfamiliar direction—purposely attracting tourists. Baum believed visitors would come for Dare County's beautiful beaches, and that would result in taxable revenue for the county. Young people simply loved having easy access to friends and the open road. (OBHC.)

50

In 1931, Manteo High School seniors were able to cross the bridge by paying a toll of 25¢ per person, a situation that often led to some people hiding in rumble seats. Back then, the only hard-surfaced road in the area was between Manteo and Wanchese. Washington Baum thought a bridge would lead to roads being paved on the beach—an inconceivable idea for most residents and politicians. (Pam Daniels Jones.)

This aerial view of Manteo in 1931 reveals the agricultural makeup of the area. Farmland is visible to the north and south. Town plots were large to accommodate huge gardens. The waterfront bordering Dough's Creek was overcrowded with wooden warehouses and fish houses on pilings two to three deep and long piers jutting out into the water. (NPS, CHNS.)

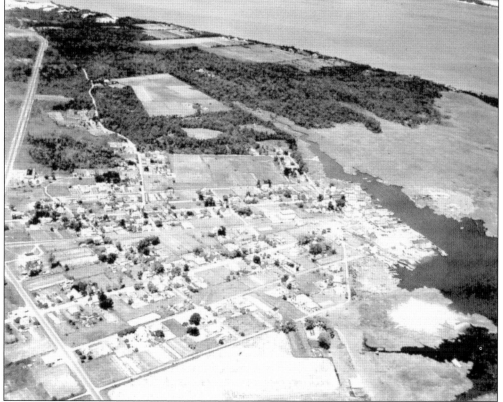

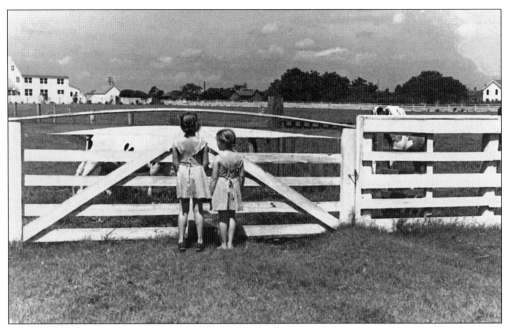

Abutting Shallowbag Bay was a Grade-A dairy farm owned by Vance Brinkley in the 1930s. Brinkley named it Hulcam Farms Dairy after his daughters Huldah and Camille. His granddaughters, also named Huldah and Camille, are shown admiring the fine Ayrshire cattle he kept. In the late 1920s, laws were put in place to ban free-range livestock and hog pens within the Manteo town limits. (OBHC.)

During his time as a three-term state senator representing Dare County, Bradford Fearing wanted the 350th anniversary of Raleigh's colonies to be celebrated in a grand manner. For years, on Virginia Dare's birthday, locals had put on a folk pageant on the north end. Fearing envisioned a theatrical play and used his influence to obtain funding and convince a young playwright to come on board at the last minute for the 1937 celebration. (OBHC.)

Pilot Dave Driskill (left) usually ferried supplies for the government, but he also took side jobs flying customers like Martin Kellogg, a young resident attorney. Kellogg, who came to Manteo after graduating from UNC–Chapel Hill, joined forces with Bradford Fearing to make a play about the lost colony become a reality. The men saw it as a way to lift Manteo out of the Depression. (OBHC.)

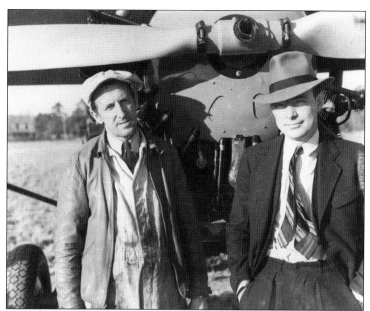

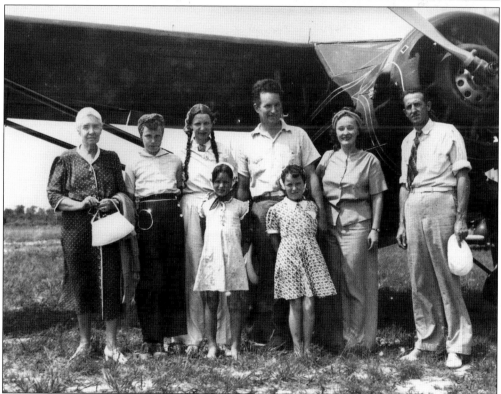

Pulitzer Prize–winning southern playwright Paul Green (center) attracted the attention of W.O. Saunders, an Elizabeth City newspaperman. Saunders and Bradford Fearing wanted the best and contacted Green about writing a script. Providentially, when Green was a student at UNC–Chapel Hill, he had come to Manteo in 1921 to watch the filming of Mabel Evans Jones's silent movie. (Ben Dixon MacNeill Collection, OBHC.)

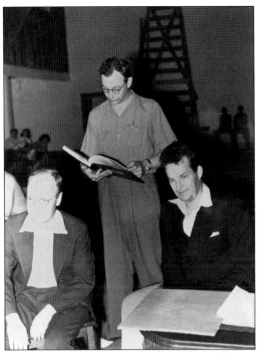

Paul Green (right) may have felt his assignment came from God, as he put aside personal reservations about the project and turned down a lucrative MGM contract. In six months, he delivered the script for rehearsals. Broadway director Sam Selden (left), and Carolina Playmakers director Harry Davis (center), brought their expertise to the experimental drama that became *The Lost Colony*. (Ben Dixon MacNeill Collection, OBHC.)

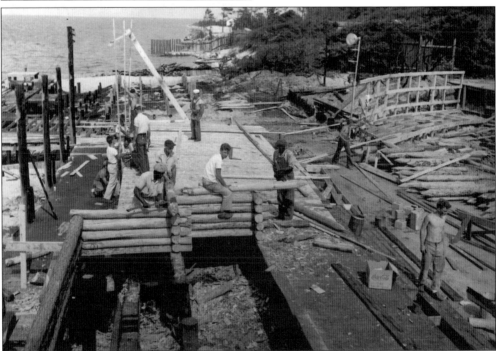

Not only did Paul Green write a script in record time, but Waterside Theatre was also constructed on the shores of Roanoke Sound at lightning speed. Albert "Skipper" Bell, an immigrant from England, was tapped to create and build the theater on the historic site of the original colony. Labor was provided by the men of the Civilian Conservation Corps, who were known around town as the "CCC boys." (NPS, CHNS.)

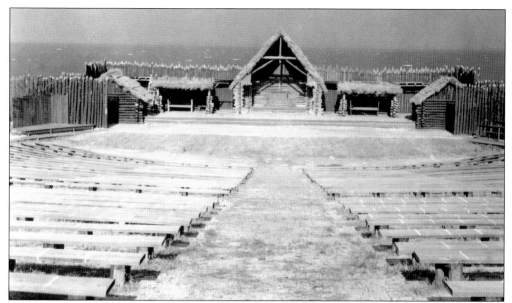

Newspaperman Ben Dixon MacNeill said Bell was like a poet in the way he dreamed up the restored site of the first settlers. The amphitheater was sculpted into the shoreline. Wooden benches sloped down to a sandy terrace and a slightly elevated wooden stage. The view of the water and being under the night sky created an ambiance in which the audience felt a kinship with the colonists. (NPS, CHNS.)

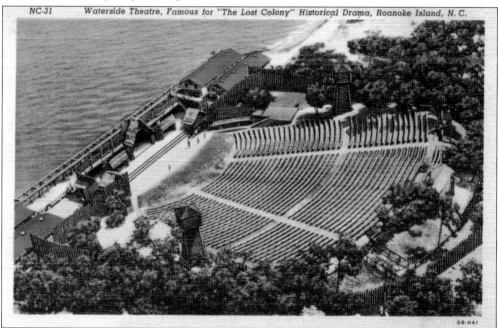

Thousands of details came together just in time for *The Lost Colony*'s opening night on July 4, 1937. Work Projects Administration (WPA) seamstresses in Manteo and Durham sewed the beautiful costumes. Actors from the Federal Theatre Project took on the major dramatic roles. The Rockefeller Foundation provided an organ, and Princeton's Westminster Choir sang the musical arrangements. (Levina Fleming.)

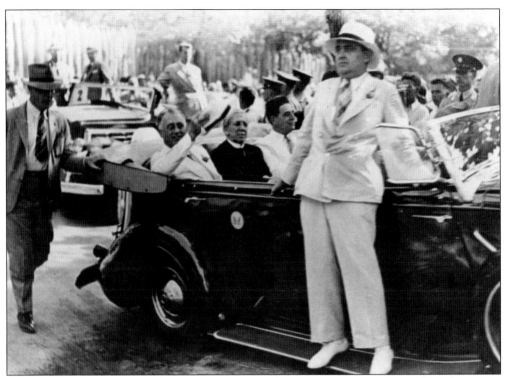

After arriving on a Coast Guard cutter, Pres. Franklin D. Roosevelt attended *The Lost Colony* on Virginia Dare's 350th birthday, August 18, 1937. A specially built ramp at the top of the theater allowed Roosevelt to watch the play from his convertible. Sharing the ramp with him was Katherine Midgett, a Manteo teenager in a wheelchair who was recovering from an operation to correct complications from polio. (OBHC.)

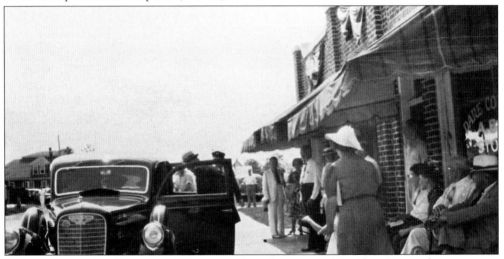

This fine car gracing the streets of Manteo may have been part of President Roosevelt's entourage. The patriotic bunting on the brick ABC storefront and townspeople dressed in their best all point to the day the president came. Roosevelt gave a brief speech before the play began, almost certainly reminding the crowd that his New Deal programs were instrumental in bringing about *The Lost Colony.* (OBHC.)

Where were all the people who came for the outdoor drama going to stay? There simply were not enough hotel rooms. The solution lay in asking Manteoers to do something that was natural for them: opening their homes to visitors. Almost every family took in strangers that first summer, and many continued to do so in the ensuing years, like at the Brinkley home, which is shown here. (OBHC.)

The waterfront was not only jam-packed with wooden buildings, it was also the location of three industrial oil facilities. M.L. Daniels had a thriving Standard Oil franchise. He had large gas tanks near the water, where fuel was loaded into barges for distribution to docks in other parts of Dare County. Concerned citizens warned that the stage was being set for a destructive fire. (Pam Daniels Jones.)

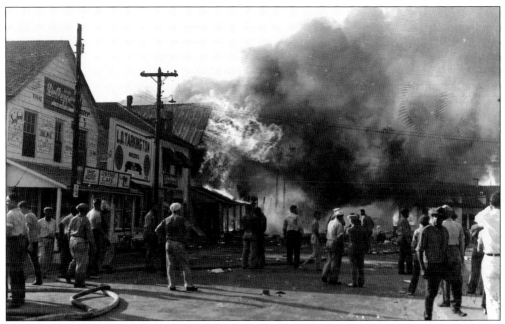

Long before 9/11 was etched into American history, September 11, 1939, was a devastating day for Manteo. A fire began in the Standard Oil storeroom and quickly spread on that windy Monday until two-thirds of the business district were destroyed. Some accounts estimated that 21 businesses, several homes, and the post office were lost. (Ben Dixon MacNeill Collection, OBHC.)

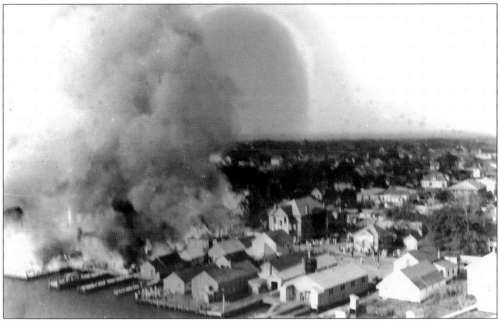

Ben Dixon MacNeill must have hurriedly taken to the air in a plane to get this shaky photograph of Manteo burning. Judge Washington Baum was reported to be the first one who tried to extinguish the fire. The alarm was sounded, but there was really no need for it, because the whole town heard and saw the petroleum drums exploding and the flames shooting into the air. (Ben Dixon MacNeill Collection, OBHC.)

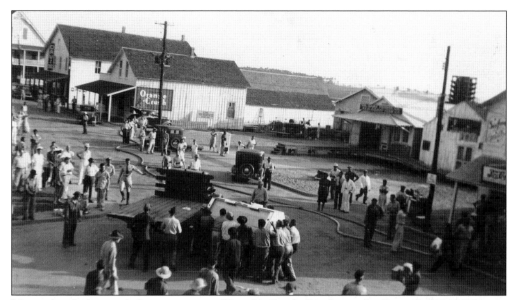

Manteo's only fire truck drew water out of Dough's Creek. Residents, the Coast Guard, CCC men, and fire crews from the beach, Elizabeth City, and Norfolk all pitched in to help fight the fire that raged on September 11, 1939. Mail was removed from the post office, and documents were removed from the courthouse. Merchandise and anything else that could be saved was spread out on lawns away from the fire. (D. Victor Meekins Collection, OBHC.)

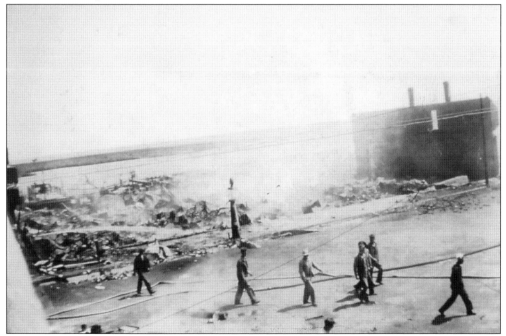

The epicenter of the inferno, Daniels Oil Company, was leveled that day. Fires occurred in Manteo before and after that day, but the Great Fire of 1939 stands out as the most devastating of them. In typical tough Roanoke Islander fashion, merchants continued to run their businesses out of homes and barns until they could rebuild. Barbers were said to have given shaves in a new locale before the ashes had cooled. (OBHC.)

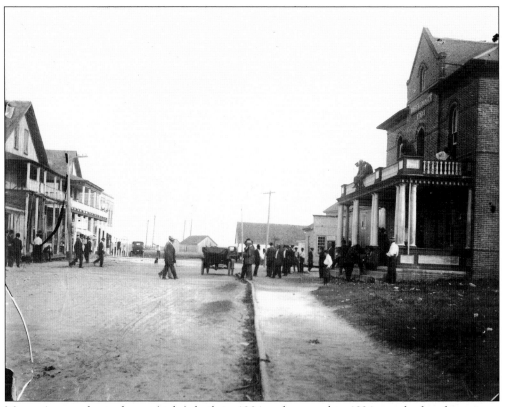

Manteo's second courthouse (right), built in 1904 and restored in 1934, caught fire three times on September 11, 1939. Each time, the Elizabeth City fire brigade extinguished the flames. In the aftermath, the Manteo commissioners used the courthouse as a model for new structures, requiring them to be built out of noncombustible materials such as brick, concrete, or steel. (D. Victor Meekins Collection, OBHC.)

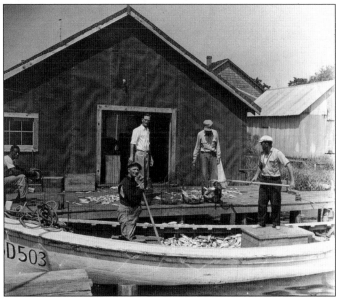

Colon Wescott opened one of the last fish houses on the waterfront around 1941. The fire marked a turning point, as Manteo moved away from industries like seafood and oil toward cultivating a more urban atmosphere. Wescott (standing near the doorway in a white shirt) is pictured buying a catch from brothers Loran (left) and Leroy (right) Midgett. (Katherine Midgett Kennedy Collection, photograph by the *Daily Advance*.)

Five

NATIONAL RECOGNITION

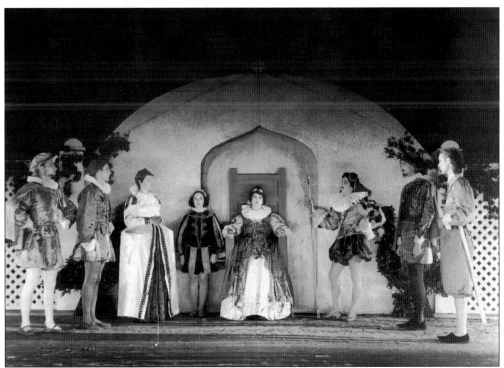

Opening on July 4, 1937, *The Lost Colony* was a tremendous hit with some 60,000 seeing it by summer's end. Initially, the play was only going to run for one summer to celebrate the 350th anniversary of the English attempt to create a permanent settlement. It was such a boon to the economy—and the locals enjoyed their participation in it so thoroughly—that carrying on into the next year seemed the logical step. (RIHA.)

Manteo's citizenry, including many CCC men, answered a casting call to have a part in the 1937 production of *The Lost Colony.* Tryouts were held in the courthouse. For decades, locals were part of the cast, playing colonists, soldiers, courtiers, and Indians. Being a child actor in the play became a rite of passage for Manteo children, even though it was an adult-sized commitment for the summer from Memorial Day to Labor Day. (RIHA.)

Producer Sam Selden (far right) is shown conducting tryouts for boys to play colonists. An accompanying press release said that the boys were hoping to one day have the starring roles of Sir Walter Raleigh, Old Tom, John Borden, or Governor White that their older brothers filled. Primary roles were usually awarded to drama students or professional actors, but some locals excelled and won coveted parts. (RIHA.)

Mabel Basnight (left) was a true believer in the dream of *The Lost Colony,* devoting 57 years of her life to the play. As Sen. Bradford Fearing's executive secretary, she was in on the ground floor of the play's creation and perpetuation and served as the box office manager until her death in 1992. Basnight collected the $1 admission fee charged in those early years and is shown here just out of college. (OBHC.)

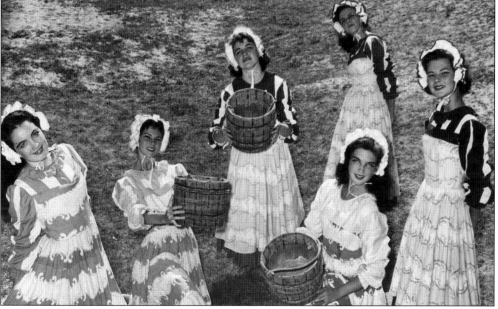

Every director has made changes in the production that reflect his own style and vision. The milkmaid dancers, who have not been in the play since 1963, are an example of the evolutionary nature of *The Lost Colony.* In the beginning, costumes were made of donated and inexpensive fabrics not specific to the Elizabethan time period. (Aycock Brown Collection, OBHC.)

The Long family—Mary, Bobby, Billy, and William (and a daughter, Laura)—invested their hearts and souls in *The Lost Colony*. Mary played Queen Elizabeth, and her husband filled many roles in management and direction. After growing up offstage and in the footlights, William Ivey "Billy" Long went on to win multiple Tony Awards in his career as a costume designer for Broadway productions. (RIHA.)

Before her novel *A Tree Grows in Brooklyn* was published in 1943, author Betty Smith moved to Chapel Hill, taking a position as a play reader for the Federal Theatre Project when *The Lost Colony* was being developed. Later, she befriended William Ivey Long and encouraged him to pursue a career in design. On "Celebrity Night" in the late 1950s, she prepared to play the part of Agona. (Aycock Brown Collection, OBHC.)

Like most alumni of *The Lost Colony*, William Ivey Long (left) feels a duty to preserve the integrity of the original intent of the founders of the play. He radically improved the costuming of the play, making it more colorful while adhering to better practices of authenticity. Every summer, he returns to Manteo, where he maintains a home, to help with scenery and costume designs. (RIHA.)

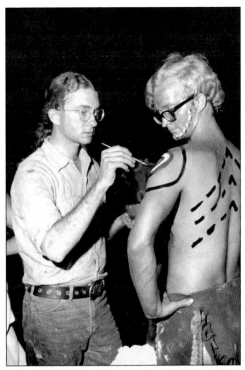

Using a musket must not have seemed like a theatrical stretch for retired Coast Guardsman John Wescott. The longtime participant once held the title of the oldest cast member. Tourist Bureau photographer Aycock Brown sent pictures and captions about Dare County life to newspapers all over the state. He knew they would be used as fillers, and when they were, the word spread about the outdoor drama. (RIHA.)

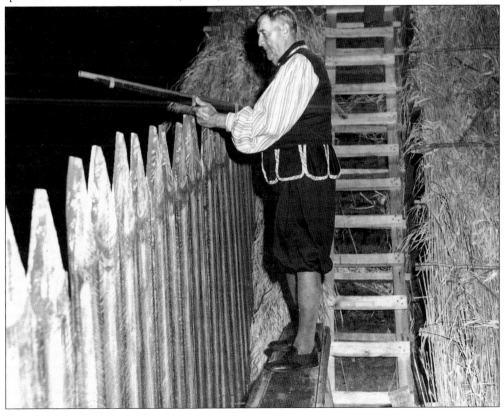

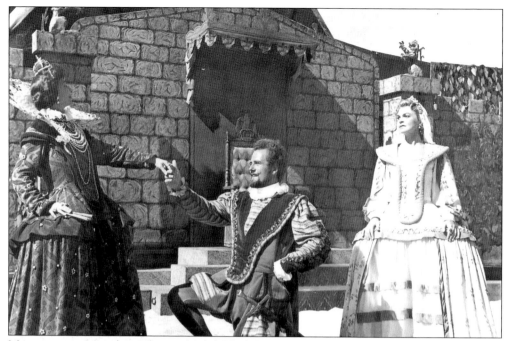

Manteo native Marjalene Thomas (right) filled almost every female role in *The Lost Colony* but is most remembered for portraying Eleanor Dare. Thomas brought to life an image of Eleanor Dare as a beautiful, resilient woman holding her baby to her chest and gazing into an unknown future. The photographed and drawn image of Thomas as Eleanor Dare became a marketing symbol for *The Lost Colony* for decades. (OBHC.)

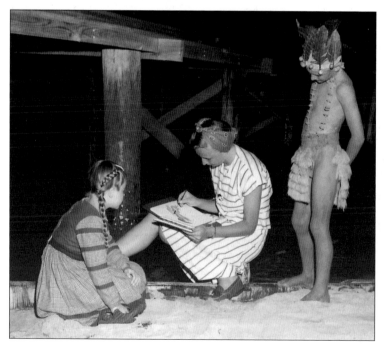

Backstage, Alice Kellogg entertained these two child actors with her watercolors. Parents had faith that *The Lost Colony* environment was safe for children. Under the watchful eyes of friends and relatives who were also in the cast, children could neither be taken advantage of nor act up. When their characters' scenes were concluded, the kids would catch a *Colony* bus home to downtown Manteo. (RIHA.)

As a child, Cora Mae Basnight played a colonist in the 1921 silent movie. As an adult, this natural comic held the role of the lovestruck Indian maid Agona for 25 years, one of the longest runs in United States stage history. Her one line in the show—"Tee-hee"—always drew laughter. She was known for jumping in the sound each night after the show to wash off the greasepaint called "Texas dirt." (OBHC.)

Cora Mae Basnight's son Marc Basnight (left) has always been known for his charming Hoi Toider accent, especially when he spoke on the North Carolina Senate floor, where he represented the Eastern District for 26 years (the last 17 as president pro tempore). Andy Griffith would mimic young Basnight's line about where he got some fish by saying, "Manteo showed us where to 'foind' them." (RIHA.)

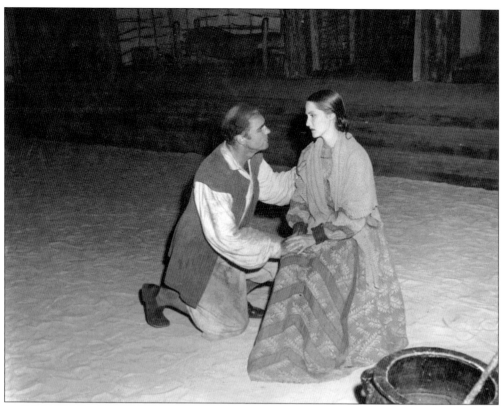

Here, John Borden, played by R.G. Armstrong, is shown comforting Eleanor Dare, played by Barbara Griffith, Andy Griffith's first wife. Armstrong met the Griffiths at UNC–Chapel Hill, where they all honed their acting skills in the Carolina Playmakers. He had a successful stage and screen career, most often playing violent characters in westerns despite an affable off-screen personality. (Aycock Brown Collection, OBHC.)

When he was a youngster, Steve Basnight Jr. (foreground) made lifelong friends with actor Andy Griffith. That bond transcended Griffith's future Hollywood stardom. Basnight eventually became a schoolteacher and then superintendent of Dare County Schools. If there were a community need, he would call Griffith at his home on Roanoke Island or in California and quickly get funding. (RIHA.)

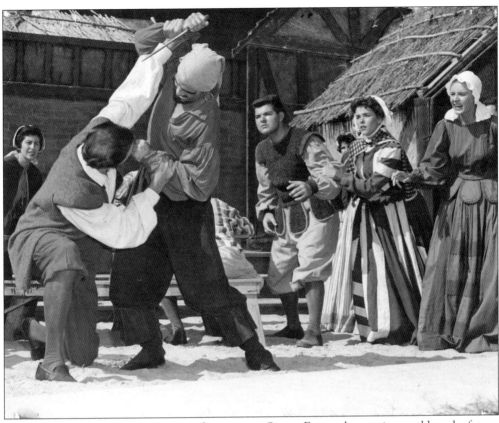

George Spence gave a convincing performance as Simon Fernando, as witnessed here by future soap opera star Eileen Fulton (second from right) of *As the World Turns*. *The Lost Colony* gave many actors a foundation for solid careers. It also attracted seasoned professionals like Lynn Redgrave and Colleen Dewhurst, who joined the cast for short-term, well-publicized stints, with both of them playing Queen Elizabeth. (RIHA.)

Paul Green's vision of a "people's theatre" was realized. *The Lost Colony* told the story of the common man while being accessible to average citizens. Sen. Josiah William Bailey proclaimed in the Manteo courthouse, "This is a sacred spot here. Let us put on a drama, here at this patriotic shrine where those brave pioneers lived, struggled, suffered, and died. Yes, let us tell their story to the world." (RIHA.)

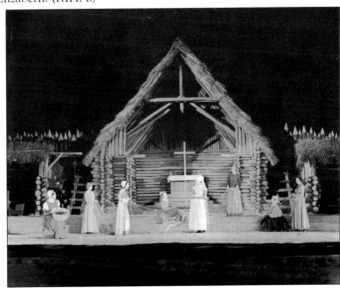

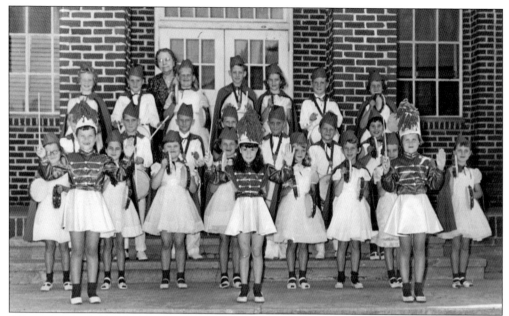

Almost every child was part of Holland Wescott's Rhythm Band. Here, she stands behind her students in an elementary recital. Holland lived with her adult sisters Hettie and Effie in the family home in Burnside that still bears the sign "The House By the Side of the Road." Holland and Effie were hostesses, and Hettie was an actress in *The Lost Colony*. (D. Victor Meekins Collection, OBHC.)

Dressed all in white, the Manteo High School Marching Band is shown parading down Budleigh Street in the 1930s. The small island school often struggled to provide resources above and beyond budgetary items. In the 1950s, Andy Griffith purchased instruments and uniforms for the band; perhaps band booster Mabel Basnight put a bug in his ear. (D. Victor Meekins Collection, OBHC.)

Six

OUTSIDE INFLUENCES

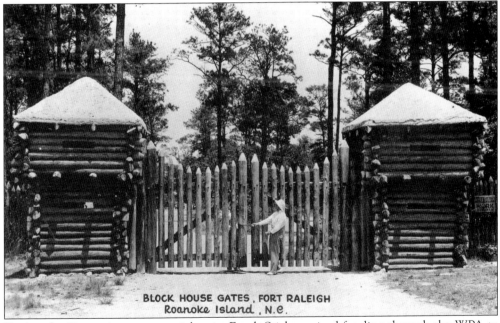

BLOCK HOUSE GATES, FORT RALEIGH
Roanoke Island, N.C.

During the Depression, commercial artist Frank Stick received funding through the WPA to design and build a replica of Fort Raleigh. With little information about how to accurately re-create the historic site, Stick and construction superintendent Skipper Bell surmised that the English would have used log buildings. This 1941 postcard shows the front entrance to the created Cittie of Raleigh State Park where Fort Raleigh was located. (Levina Fleming.)

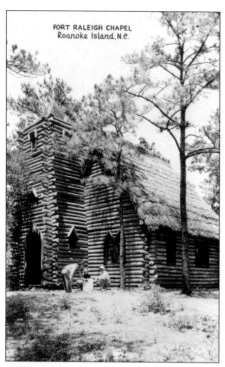

FORT RALEIGH CHAPEL
Roanoke Island, N.C.

With its thatched roof and paned windows, the Fort Raleigh Chapel was so charming that many local people were married there. The palisaded fort, rustic chapel, and other log buildings were completed in 1934. Around the same time, artist Frank Stick—who designed the re-created Fort Raleigh—proposed and worked toward the establishment of the Cape Hatteras National Seashore and the Pea Island Wildlife Refuge. (Levina Fleming.)

The first caretaker of the Cittie of Raleigh State Park, Robert Atkinson (left), is shown walking through the museum with poet and writer Carl Sandburg (center), and retired National Art Gallery counsel Huntington Cairns (right). North Carolina historian William S. Powell wrote, "The activities at the site in no small measure generated the interest which resulted in *The Lost Colony*." (OBHC.)

The framed pictures behind Capt. Jeff Hayman, caretaker of Cittie of Raleigh State Park in 1938, show a commemorative coin and photographs of log structures with stone foundations and chimneys. The Cittie was an immediate hit with the public, as visitation reached 10,000 tourists in 1935. However, hard-line historians contested its authenticity and saw it as a problem. (NPS, CHNS.)

In 1941, the National Park Service (NPS) took over the Fort Raleigh site. NPS historians concluded that the log fort blockhouse was "absurd" and would have looked better on the 1776 Pennsylvania frontier. In addition, the construction of the site led to damage being done to archaeologically sensitive areas. The WPA and the NPS locked horns in a conflict, but the NPS prevailed and had the log structures removed. (NPS, CHNS.)

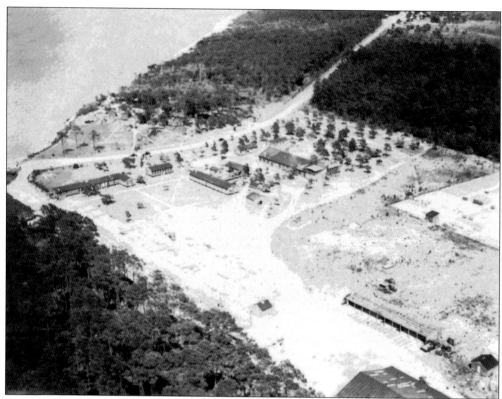

A WPA camp—first called Little Eustis Camp, then Camp Wirth, then Camp Wright (in 1938)—was established three miles north of Manteo on the Croatan Sound. The WPA, created because of Depression-era unemployment, existed to provide work for unattached, transient males. The men, who first went for conditioning at military bases, lived in barracks and followed regimented routines. (NPS, CHNS.)

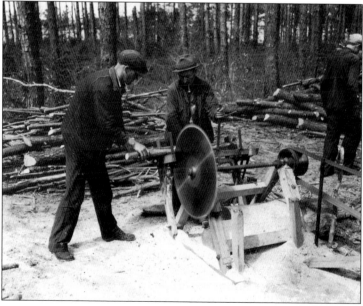

In addition to constructing the Waterside Theatre and the Cittie of Raleigh, WPA laborers (shown here in their issued uniforms) cut firewood for those who could not cut their own. Other WPA camps in Dare County used workers to improve Coast Guard properties, repair roads, paint schools, mend nets, propagate oysters, and build a gymnasium and fire station in Manteo. (NPS, CHNS.)

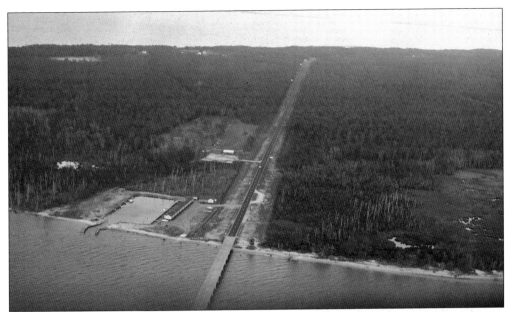

This Navy photograph of Camp Wright shows the 1955 William B. Umstead Bridge from the island's north end to mainland Manns Harbor. Many of the original barracks and buildings were gone by the time this photograph was taken. The rectangular-shaped, man-made boat basin with wooden entrance jetties projecting into the sound may have been constructed for wartime use. (NPS, CHNS.)

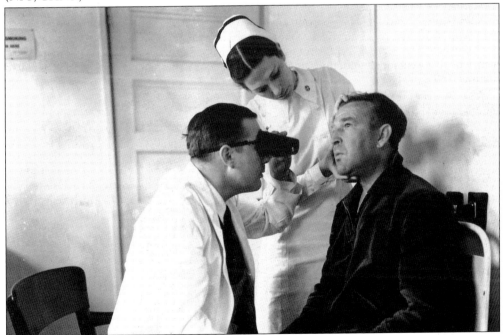

The WPA men received good health care, such as this eye exam, in the camp infirmary. A transient man in the Kitty Hawk camp who had registered for the WPA under a false name stole a car in Nags Head. A scathing newspaper article deriding the workers was soon answered with written testimonies from prominent citizens about the decency of the majority of the men. (NPS, CHNS.)

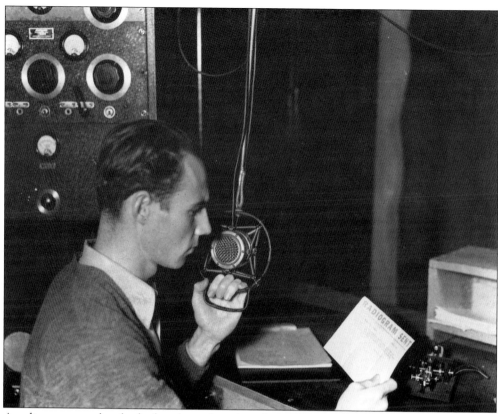

A radio operator who also had a telegraph set broadcasted at Camp Wright. On Roanoke Island, there was a CCC compound called Camp Virginia Dare near Mother Vineyard. The CCC was set up for young men ages 16 to 25, many of whom had never been away from home. A few of their many missions involved replenishing the nation's forests and controlling erosion. (NPS, CHNS.)

Doctors at Camp Wright even performed operations. The CCC men built 150 miles of oceanfront dunes from Corolla to Ocracoke. They erected sand fences and piled brush against them to collect blowing sand. They also planted beach grass and pine trees, which changed the landscape of the Outer Banks. Many of the young men married local girls and stayed in Manteo. (NPS, CHNS.)

Good food, work clothes, clean linens, and medical care were all provided in the CCC. Charles Wescott entered the CCC at age 16 in 1934 and was stationed in Buxton. He was paid $30 a month—his parents received $22, and he got the rest. His leisure time was spent swimming at the beach or climbing the lighthouse with local teenagers. Guitar music and movie screenings rounded out camp evenings. (NPS, CHNS.)

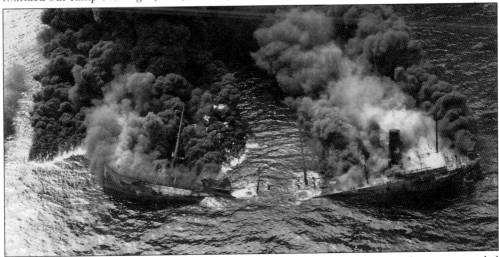

In 1942, World War II became a regional reality. Germany's Operation Drumbeat commanded U-boats to attack Allied supply ships, like the oil tanker *Dixie Arrow*. Day and night, residents could hear the explosions that resulted in cargo and dead bodies washing up on the beach. A total of 79 vessels and 843 merchant seamen and gunmen were lost in the Fifth Naval District. (Stick Collection, OBHC.)

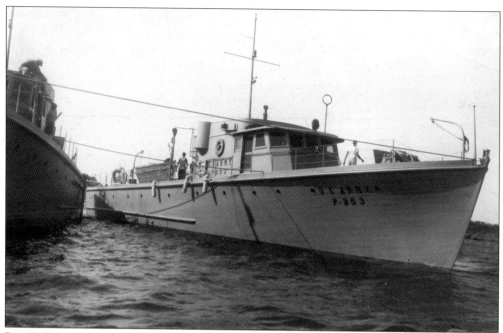

Rep. R. Bruce Etheridge helped win a War Department contract for 12 town businessmen. Manteo Boatbuilding Corporation quickly organized, leased the Creef railway property, and started turning out dinghies, specialized life rafts, and shallow and offshore rescue boats, like this patrol torpedo boat that could speed out to crash sites and pick up downed pilots. (D. Victor Meekins Collection, OBHC.)

In this wartime photograph, military jeeps are lined up in front of the Manteo bus station. The US Army's 111th infantry regiment was stationed on Roanoke Island near the entrance of Mother Vineyard. Their mission was to patrol the beaches and protect the area's bridges and lines of communication. A USO was formed in Manteo to provide morale and recreation for servicemen. (NPS, CHNS.)

Eligible island men answered the call to go to war. Many enlisted in the Coast Guard and Navy because of family traditions, in addition to their familiarity with the water. Others entered the Merchant Marines, where experienced seamen were needed to keep supplies moving. Here, Johnny Midgett (center) celebrates his birthday in the Pacific. (D. Victor Meekins Collection, OBHC.)

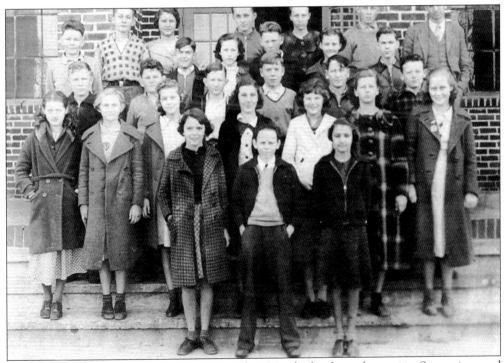

The class of 1940 shown here had to grow up fast. Men had to leave for service. Sugar, tires, and gasoline were rationed. Nighttime lights were darkened to keep U-boats from seeing silhouettes of intended targets against the backdrop of lighted towns. Even *The Lost Colony* went dark, suspending production for the duration of the war. (Katherine Midgett Kennedy Collection.)

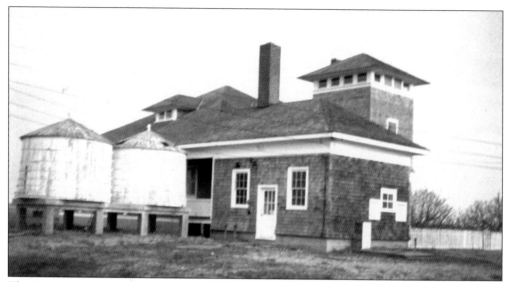

The Navy needed a nearby airport to support operations in Hampton Roads. During the war, it took over the simple Manteo airport to handle flight emergencies and continue pilot training for carrier operations. The government allocated $404,000 to make the substantial improvements shown here to the newly named Naval Air Station (NAS) Manteo. (NPS, CHNS.)

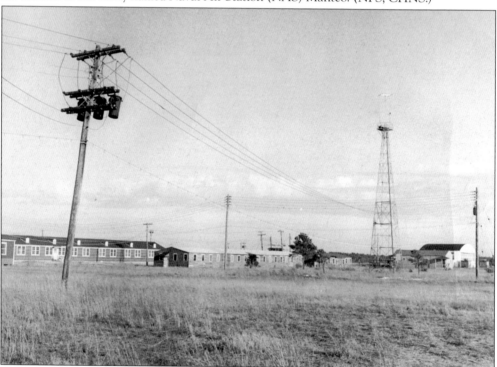

Barracks at the NAS housed squadrons preparing to fly with the Pacific fleet. Navy fighting planes, torpedo bombers, and patrol aircraft all operated out of the facility. Practice bombing and strafing ranges were on the mainland, in the sound, and at Duck. A concrete bunker used for indoor practice is now overgrown with vegetation but remains on Roanoke Island. (D. Victor Meekins Collection, OBHC.)

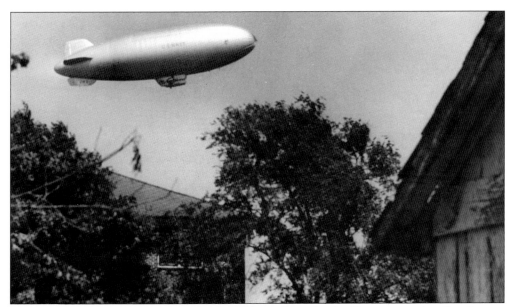

Blimps called sub chasers were used to spot U-boats from the sky. Youngsters, often Boy Scouts, were trained to recognize enemy aircraft silhouettes and engine designs. From a lookout post atop a tower perched on the Jolliff service station in downtown Manteo, young observers reported aircraft sightings to a command post using a special telephone. (Stick Collection, OBHC.)

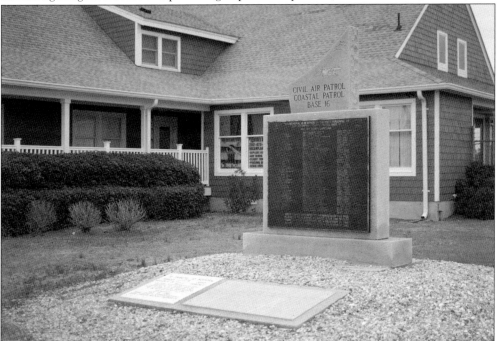

On July 21, 2012, a marker honoring the Civil Air Patrol (CAP) was erected at the airport. The CAP was formed by private citizens who rallied as modern-day minutemen when the nation was caught off guard by German U-boat aggression. Flying unarmed aircraft, they escorted supply ships, located shipwrecked sailors, marked wreckage, and acted as deterrents to brazen daytime attacks. (Francesca Beatrice Marie.)

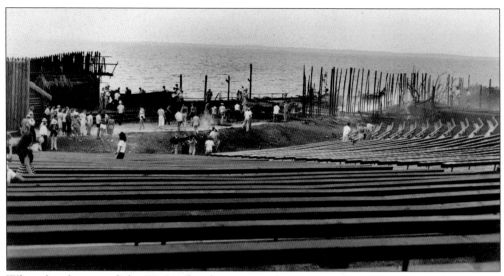

When fire devastated the Waterside Theatre on July 24, 1947, the cast and crew thought the season was over. Skipper Bell surprised the disheartened group by saying he could rebuild it if he had the manpower, and when the volunteers rallied, he did just that in an incredible six days. Reopening quickly would have been impossible if the costumes had been destroyed. (Aycock Brown Collection, OBHC.)

Wanchese native Irene Smart Raines (right) joined *The Lost Colony* as the costume designer after World War II. When fire broke out backstage in 1947, she swiftly unlocked the doors on both corridors of the dressing rooms and carried the costumes to safety. She did not, as the legend goes, throw them into the sound—she never would have done that. (Aycock Brown Collection, OBHC.)

The ancient remains of earthworks and trenches were known as Old Fort Raleigh by local people for centuries, but tradition was not historical evidence as far as the National Park Service was concerned. In late 1947 and 1948, archaeologist J.C. Harrington was brought in to search for the site of the original settlement and authenticate the earthen fort. (NPS, CHNS.)

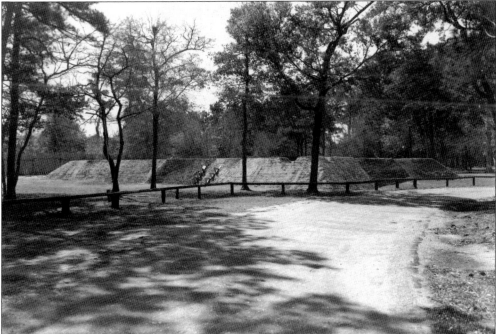

Archaeologist J.C. Harrington had worked for the NPS before, excavating a project at Jamestown, Virginia. Although Fort Raleigh's perimeter was difficult to establish, he and his team collected evidence about the location, shape, and size of the earthworks. Within a year, they had dug a ditch, piled up the dirt, formed a parapet, and leveled and grassed the earthworks for preservation. (NPS, CHNS.)

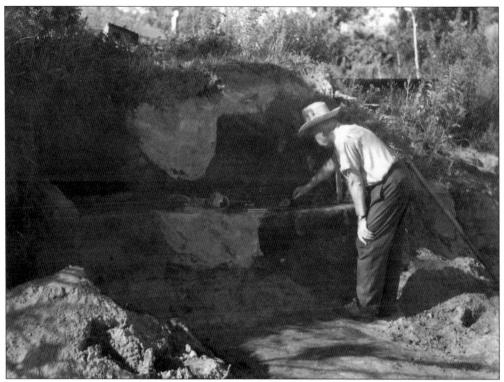

Inside the earthen walls, archaeologist J.C. Harrington found several objects of European origin, including a wrought iron sickle, casting counters, a glass bead, and a brass apothecary weight. Today's archaeologists are using 3D imaging to reevaluate the work done in the 1950s. Basic questions that are hard to answer still surround Sir Walter Raleigh's missing colony. (NPS, CHNS.)

Photographer Aycock Brown announced that Drinkwater's Folly would be the first house that travelers to Manteo would see after leaving Manns Harbor and crossing the new William B. Umstead Bridge. The home, originally built by New York sportsmen in the early 1800s, was transferred to the Dough family in 1848 and moved to the new location in the 1950s to house an antique shop. (Aycock Brown Collection, OBHC.)

Seven

A New Look

Pretty Dottie Fry's fun-loving personality made her a favorite model for Aycock Brown's promotional postcards and photographs in the 1950s. Here, she is showing off the beautiful sound-side view and a water gate—a 16th-century garden feature—at the newly opened Elizabethan Gardens adjacent to the Fort Raleigh Historic Site and the Waterside Theatre. (Aycock Brown Collection, OBHC.)

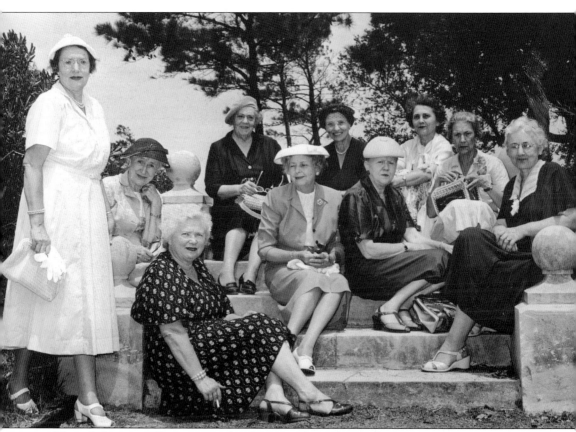

These ladies were all instrumental in bringing about the Elizabethan Gardens, once called the largest garden club project ever to be undertaken. The gardens were dedicated on August 18, 1955. Ten and a half undeveloped acres were transformed into formal English gardens complete with lush floral beds, brick architectural structures, and priceless marble statuary. A few of the women engaged in the venture were (from left to right) president of the Garden Club of North Carolina, Louise Ballard of Lake Junaluska; Mabel Evans Jones of Manteo; Irene Basnight of Manteo; Inglis Fletcher of Edenton; Bess Mitchener of Raleigh; three unidentified women; Ethel Daughtridge of Rocky Mount; and Edna Evans Bell of Manteo. They used all the connections, favors, influence, and money they had to hire internationally known landscape architects and procure donations of plants and materials. (David Stick Collection, OBHC; photograph by Aycock Brown.)

Good fortune came when the women working to create the Elizabethan Gardens received an incredible collection of antique statuary from a US ambassador's estate. In this 1988 photograph, Marie Odom, the chairperson of the board of directors, stands near a Florentine piece that was possibly a creation of Michelangelo. The ornate birdbath on the back of a lion couchant had been repaired after being damaged by vandals. (Drew Wilson Collection, OBHC.)

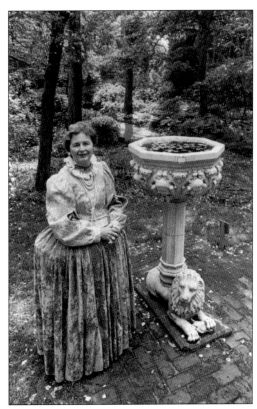

Skipper Bell, pictured here with his granddaughter, again responded to the call to serve as an experienced designer and builder when he did all of the site work and elevation preparation for the Elizabethan Gardens. Brickmasons were brought in to lay the garden walls and the gatehouse. A gardener at heart, Bell also donated azaleas, camellias, hydrangeas, and magnolias. (Cecelia Bell Smith.)

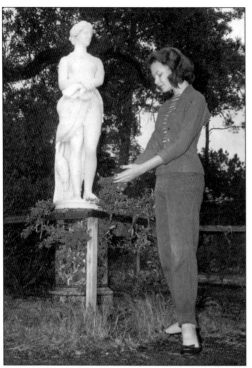

Playwright Paul Green made a gift to the gardens of a marble statue of Virginia Dare that had been on his Chapel Hill property. It had a tumultuous history of being underwater in a shipwreck, lost in a structure fire, hidden in a basement, and locked in a storage shed. The figure, carved in 1859 by American Marie Louise Landers, now has a place of honor in the gardens. (Aycock Brown Collection, OBHC.)

Another September 11 catastrophe occurred in 1960 when Hurricane Donna hit the Carolinas. Manteo has always been susceptible to flooding, sometimes due to storm drains backing up with sound water. The tide that rolled in with Donna was a record-breaker and also lingered for several days before receding. (Pam Daniels Jones, photograph by Aycock Brown.)

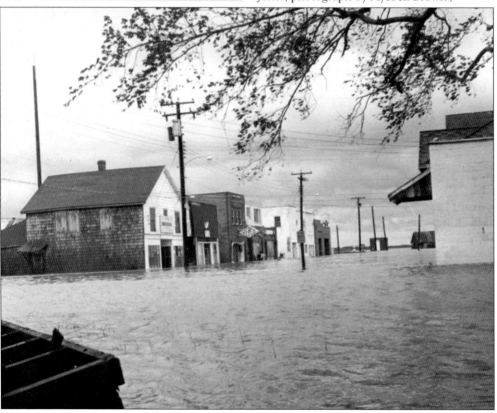

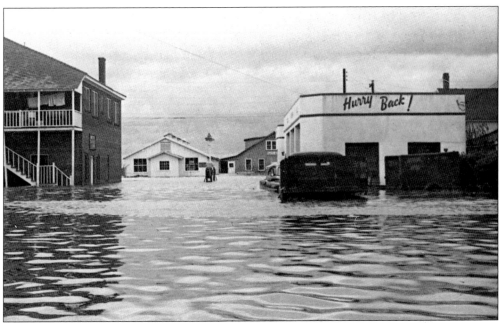

As one would expect, the Outer Banks have been in the path of many hurricanes. Three back-to-back hurricanes in August and September 1899 caused several families from Kinnakeet on Hatteras Island to throw in the towel. Many moved to a more protected Roanoke Island, with some bringing their homes on barges. Hurricanes in 1933 and 1944 had the same effect on a number of down-the-banks families who also moved to Manteo, even though flooding was an issue there, too, as shown in these 1960 photographs of the downtown area. Modern-day shopkeepers in Manteo wearily endure the financial loss and accept the extra work of flooding. However, some do reach their limits, folding up or relocating to higher ground. (Above, Aycock Brown Collection, OBHC; below, OBHC.)

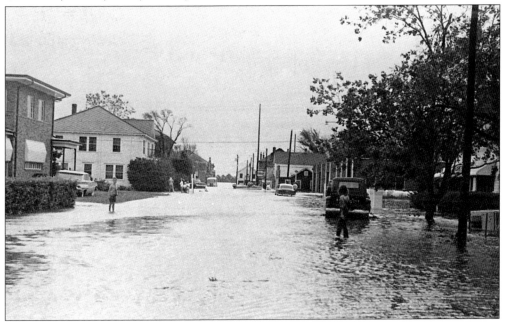

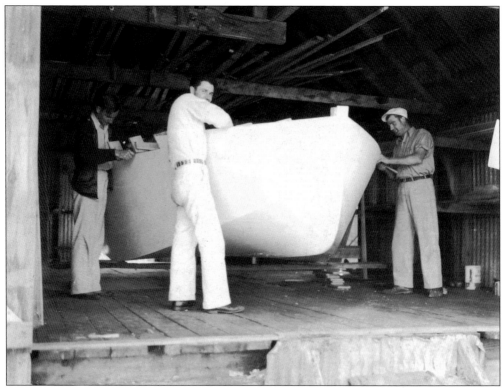

Boatbuilding has always been an industry on Roanoke Island. Dugout canoes, kunners, periaugers, sloops, schooners, shad boats, skiffs, fishing trawlers, racing boats, and ferries have been created by local builders, most of whom were not formally trained but had intuitive, natural talents. (NPS, CHNS.)

During the 20th century, demand arose for a new kind of boat when big-game anglers wanted to go out to the Gulf Stream. Warren O'Neal was one of the first commercial fishermen to make the transition to party boat fishing. He soon recognized the need for a faster boat that was comfortable and attractive. He collaborated with a fellow captain, Omie Tillett, to create a beautiful and functional sportfishing boat. (Stuart Bell.)

Warren O'Neal (shown here) and Omie Tillett combined a deep-V broken sheer with a dramatic bow flare to develop the now-classic Carolina flare style. O'Neal mentored a generation of young builders in his workshop, O'Neal's Boatworks, on Dough's Creek. His generosity and sharing of knowledge helped to create a multimillion-dollar boatbuilding industry in Wanchese on Roanoke Island. (Stuart Bell.)

Aycock Brown, shown in his military jeep, was stationed at Ocracoke with the Navy in World War II. After the war, he put his journalistic skills to work photographing, as people joked, "pretty girls and dead fish." In 1952, he became the first full-time director of the tourist bureau in Manteo, relentlessly promoting the Walter Raleigh coastland by sending his pictures and press releases to newspapers near and far. (OBHC.)

Aycock Brown's assistant at the tourist bureau, Sarah Owens, had to rely on volunteer labor—like these envelope-stuffing Girl Scouts. The operation was set up in a cramped office in the community building. The energetic Brown made friends easily and traded on those relationships to get his photographs printed. He would also send jars of fig preserves to break down any barriers. (OBHC.)

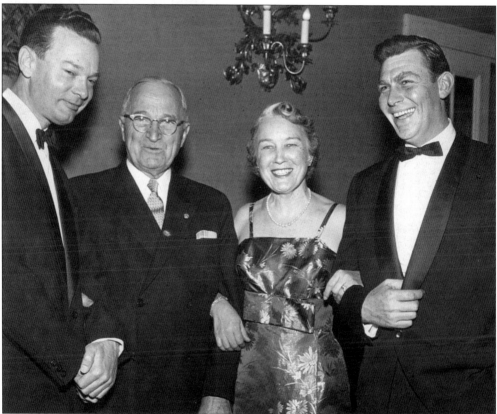

Andy Griffith (right) hit the big time when a comedic recording landed him on *The Ed Sullivan Show*. He played on Broadway and had two major hit films but is best known for embodying Sheriff Andy Taylor on his popular television show. Here, he is shown hobnobbing with (from left to right) news broadcaster David Brinkley, Pres. Harry S. Truman, and Emma Neal Morrison. (D. Victor Meekins Collection, OBHC.)

As soon as he made significant money, Andy Griffith bought 45 acres of prime north end land and maintained a second home on Roanoke Island for the rest of his life. He devoted many hours and lent his name to *The Lost Colony*, helping to nourish the production that he cherished. When he started performing in the play in 1947, he portrayed a soldier, and when he did his last show in 1953, he had played Sir Walter Raleigh for five seasons. (RIHA.)

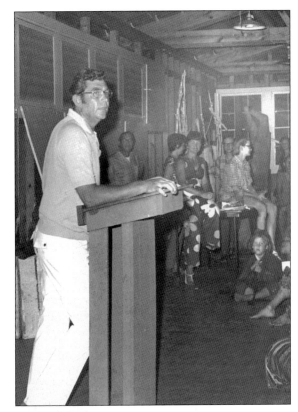

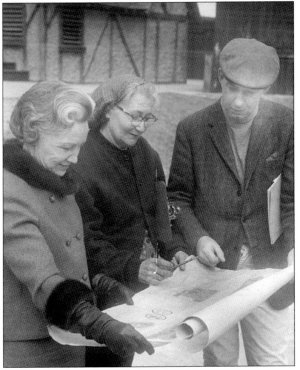

Emma Neal Morrison (left) was involved with the people and production of *The Lost Colony* for over 50 years. Using her Kill Devil Hills cottage as a summer headquarters, she fought for the symphonic drama, even serving as producer for 20 years. She was a generous giver and had an apartment complex, Morrison Groves, built to house 90 cast members. (OBHC.)

Perhaps the best thing that Emma Morrison did for *The Lost Colony* was persuading Broadway director Joe Layton (left) to come and breathe life into the faltering play. He signed on as producer and director in 1964. During his 20-year tenure, he brought "an unparalleled level of artistry onstage as well as offstage through his Professional Theatre Workshops," according to author Angel Ellis Khoury. (OBHC.)

Babies trying out for the part of little Virginia Dare threaten to overwhelm general manager Bob Knowles in this photograph. Knowles and his wife, Nancy Kaye, who played Queen Elizabeth, first started in *The Lost Colony* in 1969. A colleague said that Knowles was down-to-earth and unassuming—not theatrical in the least. (Aycock Brown Collection, OBHC.)

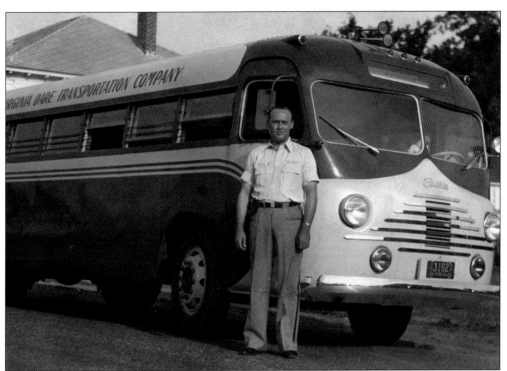

Clean and pressed, Sam Midgett stood before his Virginia Dare Transportation bus parked at the Budleigh Street station. On summer evenings between 1937 and 1954, tourists could catch the bus to see *The Lost Colony.* Locals hopped buses to the northern beach, Elizabeth City, and Norfolk to fulfill medical appointments, go shopping, and visit relatives. (D. Victor Meekins Collection, OBHC.)

Strategies used to attract tourists to the Outer Banks worked, but unfortunately, visitors were bypassing downtown Manteo and hitting the beach. Many businesses moved out to the main highway for more visibility. One anchor business on Budleigh Street was the Pioneer, a family-owned theater that has remained in its present location since 1934. (Lizann Meekins.)

In the mid-1960s, Ina Evans remodeled her Manteo Motel into the Elizabethan Inn, giving it a Tudor-style facelift. Many buildings also took on the timber, waddle, and daub look of Old England. The Creef and Fearing families got on board, building facades for the adjoining Pioneer Theatre and Fearing's Shops where clothing, hardware, and appliances were sold. (OBHC.)

Walker's Diner was the spot in town where men gathered around a special round table for coffee and news each morning. The original diner, which opened in the early 1940s, was taken in, expanded, and reinvented as the Duchess of Dare Restaurant 40 years later. The owner, Doris Walker, got a new nickname, too: the Duchess. An impressive wedding venue named 108 Budleigh is now at this location. (OBHC.)

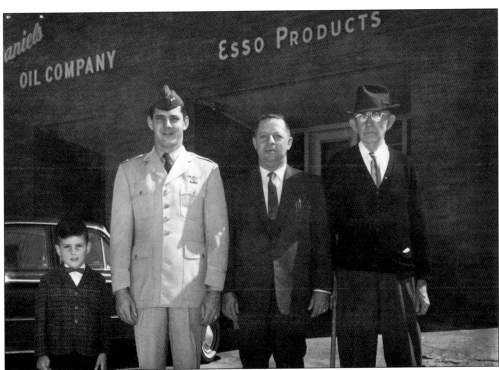

Four fellows named Moncie Lee Daniels—IV, III, Jr., and Sr.—lined up in front of the family business for this late 1960s photograph. After decades downtown, they moved the family oil company office north, erecting a tasteful building in an Elizabethan style; it is now a private residence. Moncie Sr. legally changed his name from Monsieur LeBlanc, a name bestowed on him for a character in a novel read by his mother. (D. Victor Meekins Collection, OBHC.)

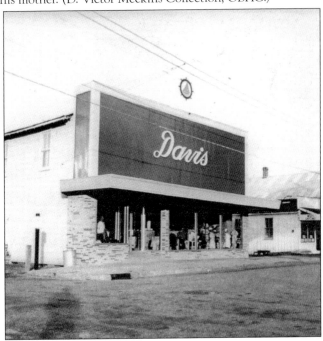

The waterfront Davis Department Store burned on a December morning in 1965. Ralph and Vernon Davis carried on the tradition started by their father, Carson, and reopened their immaculately kept haberdashery on Budleigh Street. Tourists and locals alike remember their adverting slogan shown on billboards: "Davis Wants to See You, Everything to Wear." (OBHC.)

The Davis brothers—Ralph and Vernon—were also known for their passion for racing boats. At Davis Boats, they constructed highly maneuverable hydroplane racers like the *Pat II*, with hulls that radically changed the sport. Later, Vernon, along with the Creef family, donated waterfront land and a boathouse to the town for the Roanoke Island Maritime Museum—a fitting way to honor generations of boatbuilders. (OBHC.)

The construction of a bridge to Manns Harbor left behind an abandoned ferry dock and a deep underwater hole carved out by ferry propeller action. The sandy sound-side beach became a local bathing spot. Today, the county has turned the Old Swimming Hole into a park with a covered pavilion and playground. It is situated between the aquarium and the airport. (D. Victor Meekins Collection, OBHC.)

The Roanoke School basketball team pictured here in the mid-1950s is suited up and game ready. Although the US Supreme Court struck down segregation in public education in 1954, it was not until 1965 that Manteo schools were desegregated. There were no organized protests, but neither the white nor the black community were initially in favor of integration. (Manteo Centennial Exhibit Collection, OBHC.)

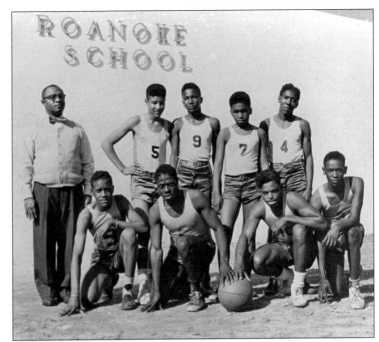

Teacher and *The Lost Colony* veteran Marjalene Thomas is pictured holding the children's attention during story hour around 1969, the year the Manteo Library opened. Citizens worked for years to raise money for the modern facility. The library had humble beginnings, starting above a downtown store in 1930 with just 14 volumes donated by the Women's Club. (D. Victor Meekins Collection, OBHC.)

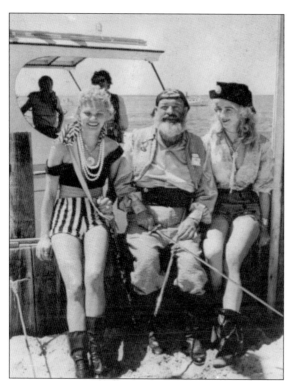

The Pirates Jamboree was a three-day festival started in the spring of 1955 as another way to draw visitors. It featured fish fries, dances, parades, beach-buggy races, and mock sea battles. The men grew beards, and the women sewed elaborate costumes. Alas, the rowdy fake pirates acted too much like real pirates, and organizers called off the whole thing in 1964. (Dottie Fry.)

The Brothers of the Brush pledged—as good, civic-minded citizens—to grow a mustache, full beard, goatee, or sideburns and wear a top hat or derby during the 100th anniversary of Dare County in 1970. From left to right are Jerry Austin, Frank Moore, Pete Cochran, unidentified, Francis Meekins, Allen Mann, Jerry Doodie, Byrum Sawyer, Carlisle Davis, and Roger Gard. (Betty Alice Mann.)

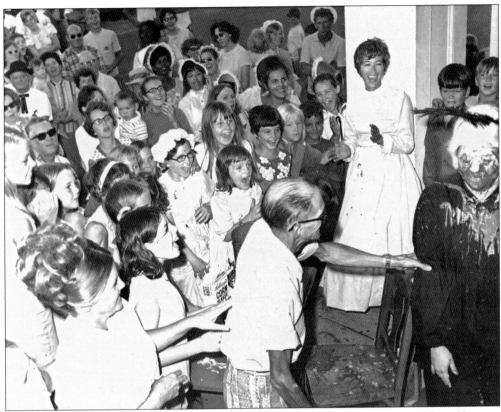

Dare County's centennial celebration was combined with the 100th anniversary of Cape Hatteras Lighthouse, which also originated in 1870. To raise money for all of the events, souvenir stock certificates were issued for $1 apiece. This picture of antics on the courthouse steps shows Jim Hasty having just given a pie in the face to Della Basnight as children and adults react with delight. (Betty Alice Mann.)

About 17 costumed Roanoke Islanders made a weeklong promotional circuit through the Pamlico area to drum up interest in the centennial in 1970. Celebration events included garden visits, teas, fish fries, contests, dances, boat races, fishing expeditions, religious services, and parades like this, in which Allen Mann is shown driving his daughter Patty past their family business, Allen's Confectionary. (Betty Alice Mann.)

Chevrolet's Hassell and Creef Motors sponsored Soap Box Derby competitions. The cars came as kits with axles, wheels, a steering wheel, a pulley system, and basic instructions. Many of these cars sported the names of family businesses. From left to right are Sammy Burrus, Freddy Gates, Robert Fuquay, Clarence Gibbs, Doc Sawyer, Paul Creef, and Stevie Hines. (Aycock Brown Collection, OBHC.)

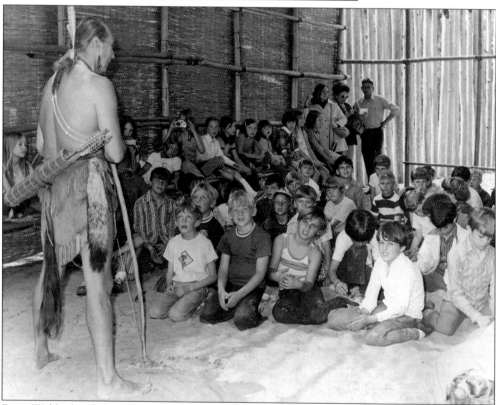

Doug Waldorf settled in Manteo and built a replica of a Native American village on the Sandpiper's Trace Campground property. He based his layout and design on John White's drawings and held powwows and seminars for visitors and schoolchildren. One day, he verified his reputation as an eccentric when he conducted business at the courthouse wearing a crow's foot as an earring. (Stick Collection, OBHC.)

Eight

REVITALIZATION AND THE 400TH ANNIVERSARY

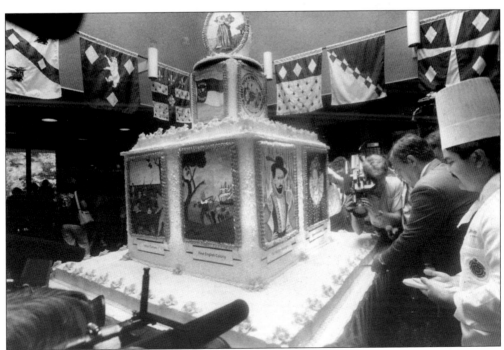

In this August 18, 1987, photograph, a pastry chef at far right looks pleased as Gov. James Martin cuts into a six-foot-tall, 1,500-pound cake celebrating the 400th anniversary of the birth of Virginia Dare. The party, which drew 700 guests, was held at the Fort Raleigh National Historic Site. It marked the end of three years of festivities honoring the 400th anniversary. (Drew Wilson Collection, OBHC.)

A long-brewing idea was brought to fruition when, in 1978, Gov. James B. Hunt appointed 14 citizens, many from Roanoke Island, to make up the 400th-anniversary committee. The task force, which included Marc Basnight (right), planned memorable events and ceremonies to take place on the island and in Plymouth, England, between 1984 and 1987. (RIHA.)

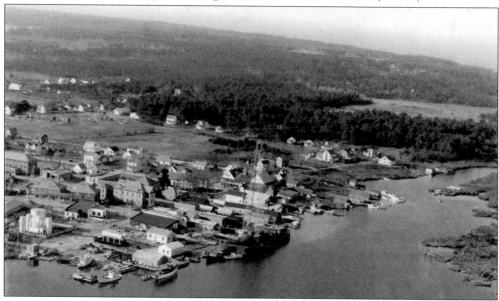

At about the same time, a young architect, John Wilson IV, returned home and was elected mayor in 1979. With a gung-ho group of town commissioners behind him, he started the race to redevelop the downtown area that had not changed much since the time this photograph was taken during World War II. Wilson and the commissioners invited graduate students from the NC State School of Design to formulate a plan. (Katherine Midgett Kennedy Collection.)

The Christmas Shop and Island Art Gallery was a well-known business on the highway owned by Eddie Greene. He once said, "I would have thousands of people going through my shop, and you could have shot a cannonball through (downtown) Manteo and not hit a soul." As a town commissioner, he helped to make Manteo's downtown a presentable place for the 400th-anniversary celebration. (Drew Wilson Collection, OBHC.)

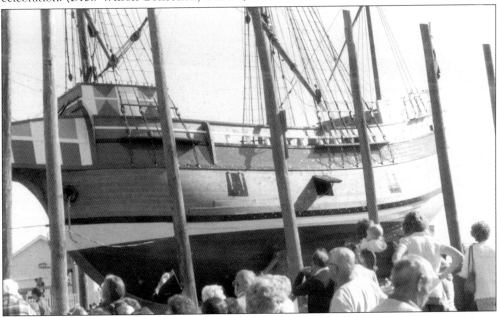

Mayor John Wilson IV also became an ex officio member of the 400th-anniversary committee, insisting that a replica of the *Elizabeth II*, the ship the colonists came over on, be built on Manteo's waterfront. The vessel, constructed using 16th-century methods, was a pet project of Gov. James B. Hunt. He intended it to be an ambassador of goodwill and education as it sailed from port to port. (RWG.)

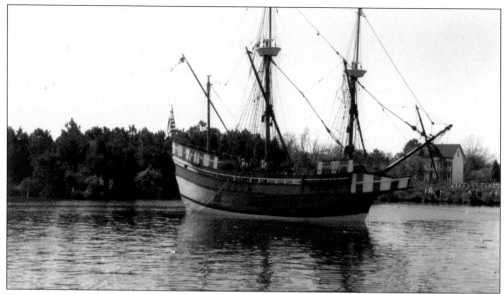

The North Carolina General Assembly agreed to develop a facility to showcase and berth the *Elizabeth II* that was launched in 1983. The Roanoke Island Festival Park, located on Ice Plant Island across from the Manteo waterfront, features an interactive museum, living history programs, and performing arts venues. The Outer Banks History Center is also part of the complex. (RWG.)

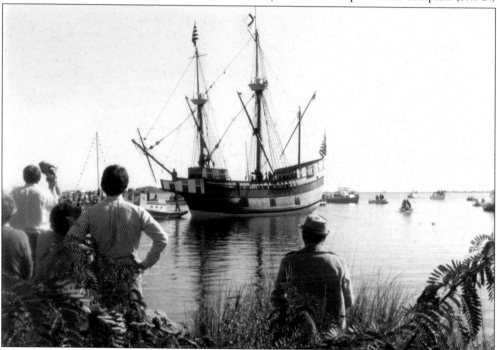

Both backward steps and forward leaps were part of the race toward the 400th celebration. A bridge had been built to Ice Plant Island, but docks and a boardwalk were still needed. Clashes about dredging channels under the new bridge and out into the sound for the *Elizabeth II's* deep draft were resolved. Demolition of decrepit buildings cleared a spot for a new shopping and residential complex. (RWG.)

Mayor John Wilson's goal was not just to prepare for the celebration but to bring about long-term revitalization. Public and private funding were vital to achieve the goals the NC State students helped to outline. Townspeople were contacted via a door-to-door survey so they could provide input about the re-creation of Manteo. The Waterfront Shops on Dough's Creek are shown here reaching toward the sky. (RWG.)

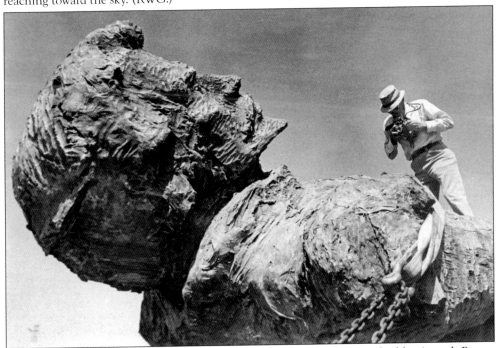

A 24-foot wooden statue of Sir Walter Raleigh, shown being photographed by Aycock Brown on the day it arrived in 1976, overlooked Manteo for 14 years. Andy Griffith, who once played Raleigh in *The Lost Colony*, was instrumental in helping Mayor John Wilson get the publicity and funding that his ambitious ideas required. Griffith made appeals to the state legislature, and Wilson filled out countless grant applications. (OBHC.)

One objective of Mayor John Wilson was to attract businesses, like Steve Brumfield's Manteo Booksellers, that would be patronized by both locals and tourists. Capital improvements went beyond the downtown area. A landscaped corridor was created to link historic sites. Communities were built for elderly and low-income citizens. Cartwright Park (in California) and Jule's Park (on the waterfront) were set apart. (OBHC.)

In another act of exuberance, the planners of the 400th-anniversary celebration invited the US president and the Queen of England to attend a ceremony on July 13, 1984. Both declined, but Queen Elizabeth did send her daughter, Her Royal Highness, Princess Anne. Princess Anne graciously toured the *Elizabeth II* and the Elizabethan Gardens, where she attended a party for 500 guests. (Betty Alice Mann.)

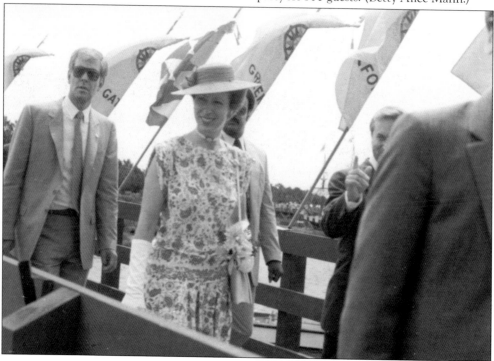

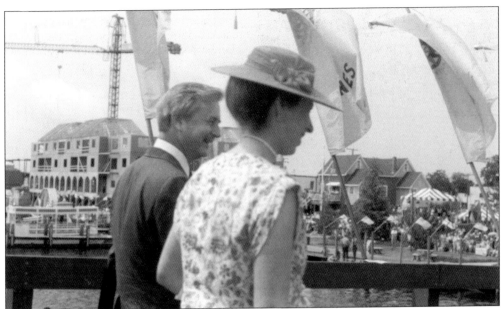

Gov. James B. Hunt proudly escorted Princess Anne along the Cora Mae Basnight Bridge walkway. The princess unveiled a marker on the waterfront that commemorated the voyages of Sir Walter Raleigh. It was similar to a plaque on the Plymouth, England, seawall, where Raleigh's voyages began. Governor Hunt was in Great Britain in April 1984 for that unveiling. (Betty Alice Mann.)

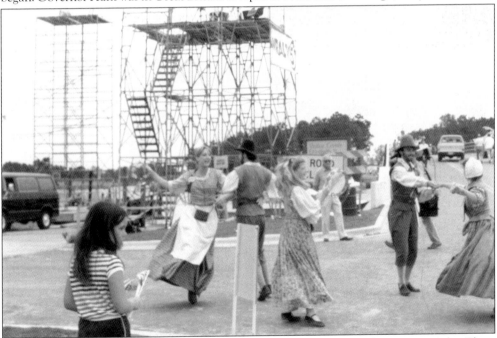

During the celebration, townspeople dressed in 16th-century garb danced in joyous revelry. There were jugglers, a falconer, dramas, and games. A town crier proclaimed London's latest news. Craftsmen plied their trades. Hot cross buns and other Elizabethan culinary delights were on offer. There were ceremonies and dedications featuring the *Elizabeth II* ship, the visitors' center, and a special US Postal Service stamp. (RWG.)

The 400th-anniversary flotilla, led by CBS news anchor Walter Cronkite, left Elizabeth City and arrived in Manteo on July 14, 1984. That day, there was also a twinning ceremony between Manteo and Bideford, England, where many of Sir Walter Raleigh's ships had been built. The Manteo delegation that went to England the previous April took part in a corresponding event in Bideford. (RWG.)

Four-year-old Susannah Miller of Raleigh tried to keep a wooden hoop rolling during the "gossyp feste" marking the 400th birthday of Virginia Dare and the end of Manteo's elaborate celebration. True to form, the people of Manteo came together, working with state officials to pull off what was an almost impossible undertaking. (Drew Wilson Collection, OBHC.)

Nine

PROGRESSIVE MANTEO

Queen Elizabeth, as played by Barbara Hird, is shown coolly approving of Tshombe Selby's carol singing at one of the Christmas-tree-lighting celebrations held every December in Manteo. Manteo's leaders, always seeking to draw people downtown, sponsor various events such as Dare Day in early June and First Friday nights each month in the offseason. Live music and street food are additional attractions. (Melody Leckie.)

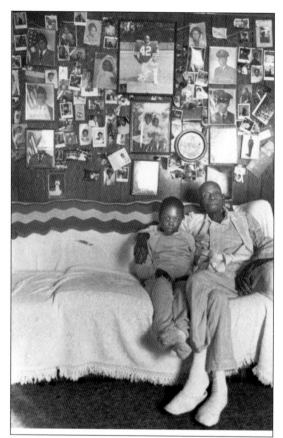

In 1989, the wall behind 108-year-old patriarch John Robert Drake was covered with images of his numerous descendants. His great-great-grandson at his side, Tshombe Selby, showed incredible singing aptitude as a child and is now an operatic tenor. After moving from Manteo to Manhattan to perfect his acting and voice skills, Selby is now an up-and-coming talent. (Drew Wilson Collection, OBHC.)

In 2000, Dare County built a modern justice center complex on the main highway, which rendered the old courthouse an empty relic. County commissioners approved a project to restore the old building to its original design, right down to a belfry that had blown off in the 1933 hurricane. The Dare County Arts Council received a permanent home in the renovated courthouse in 2010. (Francesca Beatrice Marie.)

The Lost Colony brought exposure to the arts to locals like Mollie Fearing (right, in 1985), and they passionately wanted to share that feeling with future generations. Mollie Fearing was one of the founding members of the Dare County Arts Council. An annual art show and its prestigious award, the Mollie, are both named for Fearing. Her daughter Grizelle (center) and granddaughter Courtney (left) continue in her footsteps. (RIHA.)

The original running time of The Lost Colony was over three hours. For modern attention spans, it has been pared down to two hours, although this led to the cutting of many extra parts that Paul Green wrote for locals to play. Island children still try out for roles, though, much like these youth did in March 1974. They are, from left to right, Randy Forrest, Gino Forrest, Cindy Wescott, Barbara Beer, Ginny Dinwiddie, and Claudia Fry. (Aycock Brown Collection, OBHC.)

113

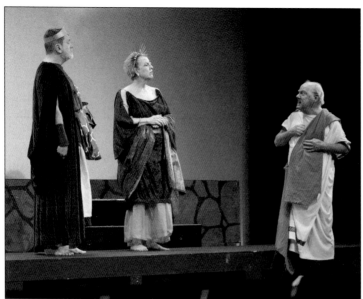

Aspiring thespians now have options outside of *The Lost Colony*. The Theatre of Dare, a nonprofit troupe of volunteer actors and production hands, has brought shows to the community since 1991. In February 2019, they mastered the challenge of Shakespeare; here, Tim Haas (left), Penelope Carroll (center), and Don Bridge are shown bringing *A Midsummer Night's Dream* to life. (Francesca Beatrice Marie.)

Celebrated CBS newsman Charles Kuralt filmed a segment of *On the Road* at the Fort Raleigh site in 1975. The North Carolina native specialized in traveling back roads and talking to the ordinary people of the United States. Kuralt's retired parents lived in Southern Shores, and the Outer Banks became a place that he frequented and loved. He once interviewed Aycock Brown for his program. (OBHC.)

With a keen eye for beauty, surely
Aycock Brown chose Jule Scarborough
to add interest to a photograph of a
new Manteo seal. The trailer in the
background may be the temporary
town hall that was destroyed in a 1976
storm. Over the decades, town officials
have also met in the courthouse,
the fire station, a waterfront office
building, and a renovated home.
(Aycock Brown Collection, OBHC.)

In 1999, a permanent town hall was established in the old East Carolina Bank building that was
acquired when the bank relocated to a new structure on the main highway. The roomy facility
also houses the Manteo Police Department. The modern town seal, reflecting local values, reads:
"Town of Manteo. Preserve. Prosper." (Francesca Beatrice Marie.)

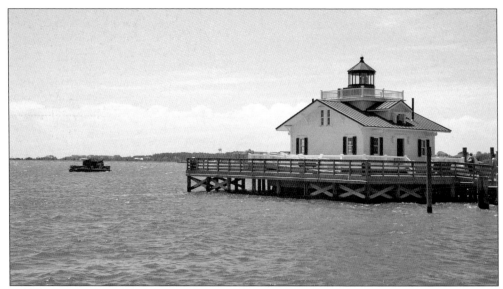

Oddly enough, the symbol for the Town of Manteo is Marshes Light, a 2004 replica of an 1877 screw-pile lighthouse that was located on the southern entrance of the Croatan Sound in Wanchese. The replica is a definite improvement over the sewage plant that once graced the eastern waterfront. The lighthouse, with its 40-yard walkway, is a popular venue for weddings. (Francesca Beatrice Marie.)

Shoppers take a moment to relax in George Washington Creef Park during a Saturday-morning farmers' market. In the background, Shallowbag Bay Club condominiums line up around a private marina. Just north of that development is the Marshes Light community, which consists of multiple- and single-family homes and has a boardwalk connecting the neighborhood with downtown. (Francesca Beatrice Marie.)

A person gets the feeling that he is not in Manteo anymore in Pirate's Cove. Located at the foot of the bridge to Nags Head, Pirate's Cove is a sprawling, upscale development with enough amenities to keep a visitor from ever wanting to leave the property. Manteo is the only municipality with water and sewage treatment plants, which made the annexation of Pirate's Cove possible. (Francesca Beatrice Marie.)

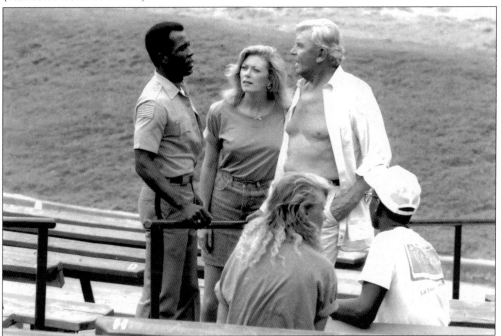

After some career setbacks and a debilitating illness, Andy Griffith was again riding high with the success of his television series *Matlock*. In 1989, he wanted to bring the show to Roanoke Island, the place to which he felt the strongest tie. Filming for this scene (in the episode *The Hunting Party*) took place at the Waterside Theatre; Griffith is pictured with Clarence Gilyard Jr. (left) and Nancy Stafford. (RIHA.)

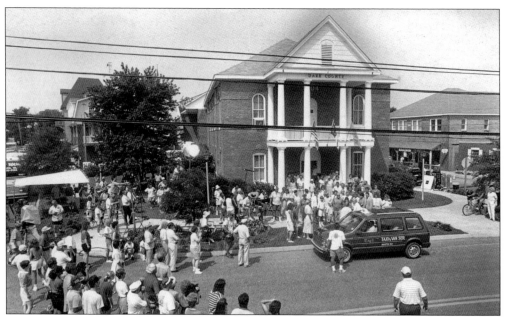

The production company behind *Matlock* hired extras by the dozens and about 20 crew members. On the downside, the 1989 episode filmed in Manteo put a spotlight on the island and revealed Griffith's secret retreat. As an intensely private person, Andy Griffith liked coming to Manteo because the natives would not dote on him. More than one autograph-seeker received a very non–Andy Taylor response from Griffith. (Drew Wilson Collection, OBHC.)

Andy Griffith's character Ben Matlock is shown shaking the hand of real-life mayor John Wilson IV as the crowd cheers the fictional lawyer's courtroom victory. This cheer was not just acting but a real response of heartfelt emotion for all that Griffith did for the town. During his *Lost Colony* days, Griffith strolled the Manteo streets barefoot, fostering friendships that endured for his entire life. (Drew Wilson Collection, OBHC.)

Growth in tourism and business brought about a need for labor in the hospitality and boatbuilding industries that could not be filled by college students home for the summer. Hispanic immigrants, like Marcos Hernandez, made their way to Dare County for financial opportunities. These immigrants and their families have ingratiated themselves in island school, church, and work environments. (Francesca Beatrice Marie.)

The world came to Manteo's doorstep again when summer workers from Eastern European countries came for jobs at retail businesses. Many young adults then applied for student visas so they could attend the Dare County Campus of College of The Albemarle (COA). In this 2016 picture, Hristina Trajkoska of Macedonia flashes her hard-earned tuition money in front of coauthor Wayne Gray. (Francesca Beatrice Marie.)

College of The Albemarle (COA) has two campuses just miles apart, but plans to consolidate and update facilities are in the works. The Twiford Road campus may be used for a dual-enrollment program for high school students who want to get a jump on college. The old middle school remaining on the US Route 64 campus will be razed so more buildings can be added in the style of the professional arts building, shown here, that was completed in 2010. (RWG.)

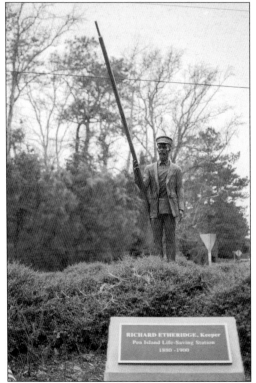

A bronze statue of Richard Etheridge holding a rescue boat oar stands in a traffic roundabout on Sir Walter Raleigh Street. Born into slavery in 1842, Etheridge distinguished himself as a man of integrity during the Civil War and as a surfman in the US Life-Saving Service. He was appointed keeper at the Pea Island station and was the first man of color to hold that job. (Francesca Beatrice Marie.)

Manteoers continue to preserve special places. The Collins Park Project is an ongoing endeavor to replicate Rodanthe's Pea Island Life-Saving Station. In 2006, the cookhouse was moved to Roanoke Island and restored so that it could display artifacts used by the all-black crew, which was known for extreme acts of bravery. The boathouse has an actual surfboat on loan from the NPS. (Francesca Beatrice Marie.)

Unabashedly built with bootlegging money, the brick Hotel Fort Raleigh was the premier lodging spot in the 1930s. After its heyday, it became Dare County's administrative offices in 1974. When empty, it lingered on the market for some time and finally succumbed to the wrecking ball in 2019. Manteo leaders plan to convert the property into green space and visitor parking. (Francesca Beatrice Marie.)

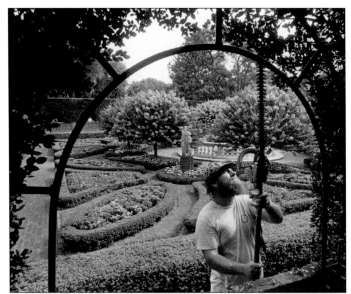

David Veltri, assistant superintendent of the Elizabethan Gardens, is pictured trimming a yaupon holly hedge in 1988. After a place of cultural and historical significance is developed, the question arises: how to keep it going financially? The gardens offers diversified events, including the WinterLights program that has turned what was once the slowest month of the year into one of the busiest. (Drew Wilson Collection, OBHC.)

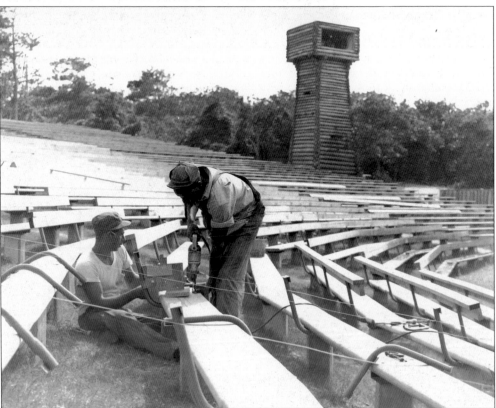

Thinking of creative ways to appeal to new generations of visitors and securing the funds to develop ideas and to sustain existing conditions can be all-consuming. As tourists' expectations evolve, changes must be made to meet those higher standards. One example occurred when two unidentified employees installed backrests on the Waterside Theatre benches in the mid-1950s to make playgoers more comfortable. (RIHA.)

Established by the state in 1976, the Aquarium on Roanoke Island is a favorite tourist destination. On rainy beach days, the attraction is filled to capacity. Among its many enticements are a 285,000-gallon shark tank, a sea turtle rehabilitation center, and live animal displays. It was updated in 2016 with a $6.5 million renovation. (Francesca Beatrice Marie.)

In 2012, the Coastal Refuges Gateway Visitor Center was built with the purpose of encouraging exploration of nearby wildlife refuges and bringing much-needed revenue to counties with fewer economic advantages. One lobbyist joked during native son Sen. Marc Basnight's influential tenure that if all the money poured into Roanoke Island were actual silver dollars, it would sink the island. (USFWS.)

Dare County partnered with Tyrrell and Hyde Counties to establish the Regional Communications Center near the airport. Telecommunicators dispatch first responders, skillfully handling 911, police, EMS, fire, and ocean rescue calls. In Dare County, it provides services to 34,000 year-round residents and a population that swells to over 350,000 in the summer. (Francesca Beatrice Marie.)

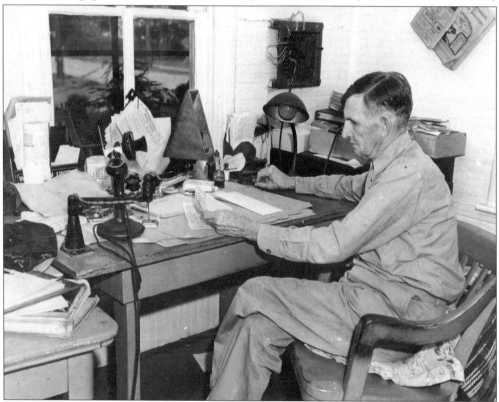

Locals deal with seasonal inconveniences like heavy traffic and long lines. Everyone must acknowledge, however, that the higher standard of living and quality of services that are the result of a tourist-based economy are worth some hassles. The town fathers who struggled to make Roanoke Island known, like Alpheus Drinkwater, could not have imagined the scope of their success. (D. Victor Meekins Collection, OBHC.)

Manteo remains a remarkably friendly town, but the influx of people has brought about a measured loss of trust. Just a few decades ago, locals left their houses unlocked and their keys in ignitions. Octogenarian Betty Alice Mann said that when she was growing up, "You knew everyone. Children could walk downtown alone or at night. No one dreamed of any danger in that." (OBHC.)

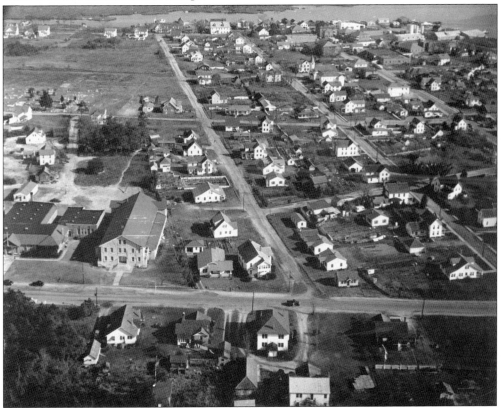

Betty Alice Mann explained, "Back then, if anyone caught fish, all the neighbors got fish. If anyone went hunting, all the neighbors got fowl. My grandparents shared from their large garden, canned vegetables, and had a pantry full." In this 1930s-era aerial photograph, there are few large trees, which may have been a way to ensure that gardens got plenty of sunlight. (Katherine Midgett Kennedy Collection.)

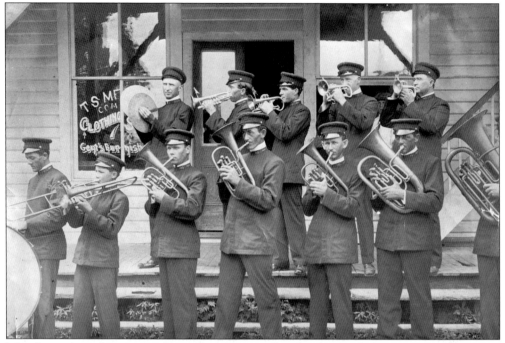

Like these talented musicians playing together to make a lovely sound, the pacesetters of Manteo have blended creative personalities to make it a one-of-a-kind place. Town planners are not content with past successes but strive to continue on a path of excellence and progress. As of 2019, a plan for the next 20 years of change and growth is being worked up. (D. Victor Meekins Collection, OBHC.)

Andy Griffith patterned his fictional Mayberry, North Carolina, after Manteo. The honest-to-a-fault characters who sat on porches and visited after church on Sunday were derived from Manteo folks. Long-standing Manteo sheriff Frank Cahoon was also emulated by the actor because he never wore a gun and often talked offenders into turning themselves in. (D. Victor Meekins Collection, OBHC.)

It has been said that people who live on islands are usually more amiable because they are dependent on one another and, more often than not, are kin. Manteoers have not minded asking people in high places for assistance, and in turn, people with power have been happy to help the little town and its inhabitants, who are easy to love. (D. Victor Meekins Collection, OBHC.)

There are a few locals who can repeat the whole script of *The Lost Colony* word for word. One of the most beloved scenes occurs when Old Tom, a town drunk in England, is transformed into a dependable watchman who looks after multiple souls. He cries into the night air, "Roanoke, O' Roanoke! Thou hast made a man of me!" It is a line that rings true to all who live in such a splendid place. (RIHA.)

DISCOVER THOUSANDS OF LOCAL HISTORY BOOKS FEATURING MILLIONS OF VINTAGE IMAGES

Arcadia Publishing, the leading local history publisher in the United States, is committed to making history accessible and meaningful through publishing books that celebrate and preserve the heritage of America's people and places.

Find more books like this at
www.arcadiapublishing.com

Search for your hometown history, your old stomping grounds, and even your favorite sports team.